The Art and Life of an Icon

Susan Seid with Jen Renzi
Photography by Steven Meckler

ABRAMS, NEW YORK

Contents

Foreword

by Susan Seid
President, The Vera Company

Vera Neumann was an unlikely revolutionary—her tiny five-foot-tall frame typically dressed in mod tunics and a bold scarf, armed with a quick wit but a shy demeanor. But Vera—the innovator of cross-licensing and one of the most successful female entrepreneurs of her time—had a radical philosophy: fine art should be accessible to everyone, not just a select few. She believed that artwork should not be relegated to walls. Rather, people should surround themselves with art—wear it, eat off it, and sleep under it. And why not? Great art endures. It lifts your spirit and makes you feel better. Vera's art certainly does. It is bright, happy, and inspirational.

In the 1960s, Vera's designs were everywhere—in the press, fine department stores, tied on the necks of stylish women, and decorating the homes of my neighbors, my friends, and pretty much everyone I knew. We all had the towels, placemats, and sheets brimming with Vera's cheerful flowers or trendy geometrics. Our mothers coveted their Vera scarves and wanted to be the first to wear the latest Vera blouse or dress. For over four decades, Vera's artwork brightened up homes across America. Woven into the fabric of this country, she was part of our lives. She was also a role model, someone whose independence, adventurousness, and entrepreneurial spirit were inspiring to young women like myself. Vera was also a pioneer in so many ways: because people were copying her work, she was one of the first designers to copyright her art; she embraced a global perspective long before it was popular; and she became a working single mother—raising two children. Her ability to juggle multiple and seemingly contradictory roles with such grace was truly inspirational.

I grew up in an environment similar to the one that inspired Vera, who was nurtured by creative parents and lived surrounded by modern art and architecture, including a home and showrooms designed by Marcel Breuer. I, too, was raised by an artistic family: my father, Charles Fink, was a professor of industrial design at Syracuse University, while my mother, Jeanne, made hooked rugs based on her original designs. My childhood home outside of Boston was strikingly contemporary with walls of glass and an open floor plan. Our furniture, some of which was designed by my father, had clean lines reflecting the mid-century design philosophy. Our neighbors were artists and our house was filled with paintings and sculpture. I spent many hours in art class at school and drawing at home. In many ways, it feels as if my own life has come full circle: as president of the Vera Company, my days are spent creating designs from colorful artworks—and studying the life of the visionary who created them.

How I came to run the Vera Company is a tale of luck and good fortune. In 2003, I first interviewed at the Tog Shop, the company that had purchased the Vera assets in 1999. The president at the time led me through a warehouse, up a flight of stairs, and into a storage area. Walking through the door, I felt like I had stepped into the scene from The Wizard of Oz, where everything changes from black-and-white into Technicolor. Hanging in the room were thousands of scarves in sophisticated designs and brilliant colors. Past a second room of scarves was another room filled with Vera's original art—drawings, watercolors, ink paintings, paper collages, and more. The experience was nearly overwhelming. Why was this amazing collection here, tucked away in the back of a warehouse in rural Georgia? Why wasn't it available for everyone to enjoy? It was one of those rare moments when you know in your heart that your life has just changed.

I accepted the position of vice president (how could I not?) with The Tog Shop's promise that once their business improved, I could embark on the mission to bring Vera's art back into public view. When sales improved two years later, the owner of the company decided to sell the entire business. With no idea how the details would be worked out, I asked to buy the Vera assets in order to revitalize the brand. I have learned that when you hold an idea firmly in your heart, the means to make it happen are already in place.

And the universe stepped up and provided support. Vera's designs can once again be found on scarves, dresses, placemats, dishes, bedding, and more. People who remember Vera from the sixties and seventies are thrilled to see her back in the limelight. It fills them with nostalgia, taking them back to a time when life in this country was simpler (and perhaps more colorful). For those who are just discovering Vera for the first time, it brings a smile to their face and warms their heart. We say that they get bitten by the ladybug.

Compiling this book was a similar feat of serendipity, discovery, and unbridled enthusiasm. Assembling the details of Vera's life and career was like an archaeological dig, pieced together through archival research, recollections from her family members and former colleagues, and, of course, through her luminous scarves and home textiles—which tell a story all their own.

So believe in your dreams and your ability to make them happen. Vera did, and I do, too.

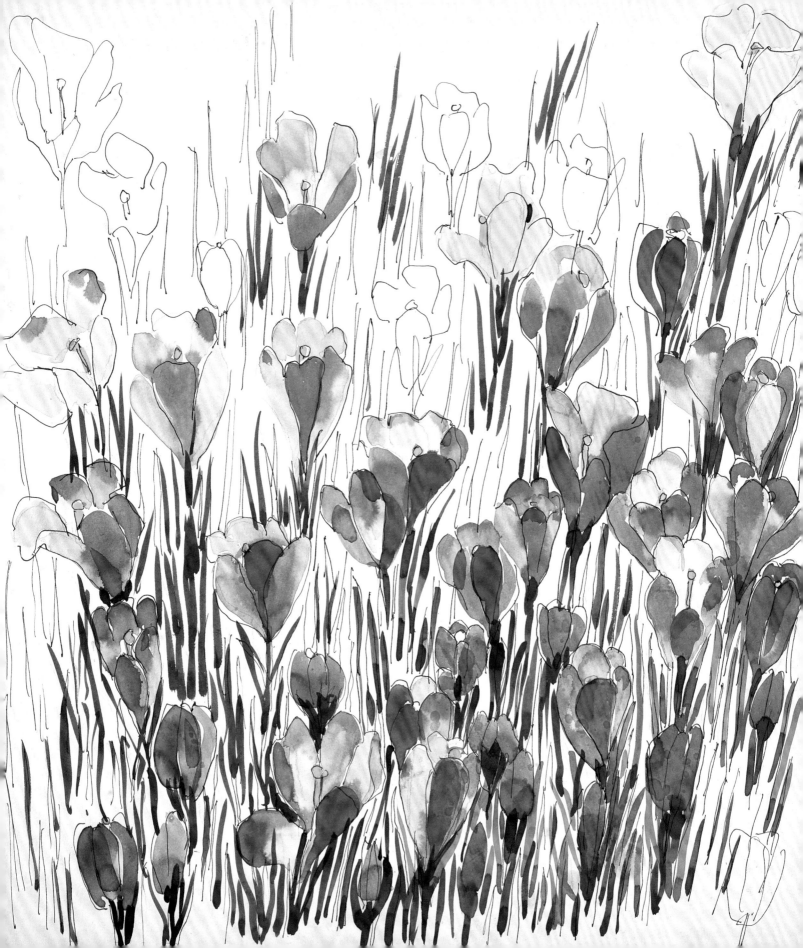

1

The Lady Behind the Ladybug

"I'm lucky. I've always happened to be at the right place at the right time."

—Vera

*F*or five decades, women in this country were on a first-name basis with Vera Neumann. Over the course of her career, which spanned the half century between her label's 1942 debut and her death in 1993, the tastemaker designed everything from wallpaper, bedding, and tablecloths, to dresses, blouses, and, of course, her signature scarves, signed like a painting with a cursive "Vera." All were based on her original artworks, which typically featured painterly florals or imagery inspired by her globe-trotting to far-flung destinations. Although she often traveled with her beloved husband, George, or colleagues, she just as frequently journeyed alone—quite unusual for a woman at the time.

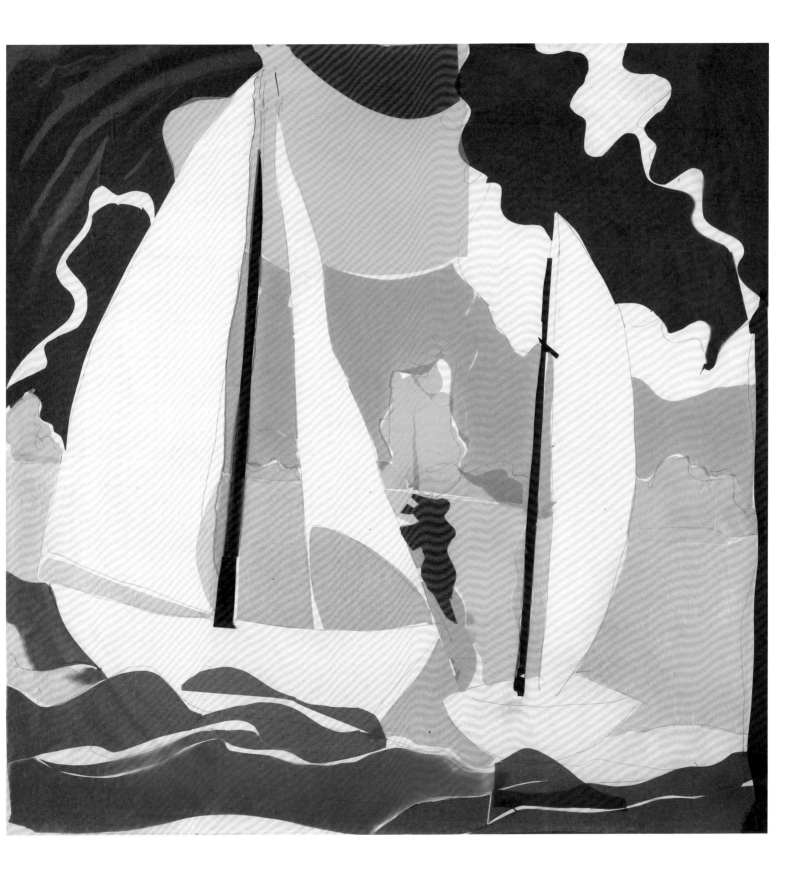

Indeed, Vera's enormous fan base lived vicariously through her adventurous life. A $10 scarf was not just a fashionable accessory to perk up a neckline but a one-way ticket to an exotic place or time, whether a historic Mayan ruin, the sun-drenched isle of Ibiza, or a future that promised women's emancipation. Vera was an early feminist icon, although in her typically humble way, she was the last to admit it. "I skipped that whole period of women fighting discrimination in business," she said. "I never had to fight my way up."[1] Be that as it may, Vera's life offered Technicolor proof that it was possible for the modern woman to have it all. As Rea Lubar, her friend and longtime press agent, said of her, "Vera couldn't decide whether to be a wife, a mother, an artist, a business entre-preneur, or a world traveler. So she was all of them."[2]

Left: A whimsical drawing of an umbrella-topped market cart became the repeat for a colorful silk scarf. The drawing that inspired it is above.

Top and opposite: Vera's artistic curiosity extended to household objects and other quotidian motifs such as milk carts and sewing kits. Her sur-roundings always provided ample fodder for her designs.

#827

school
Buss

#863

#815

8.96

863
896
827
815

#790

#788

706

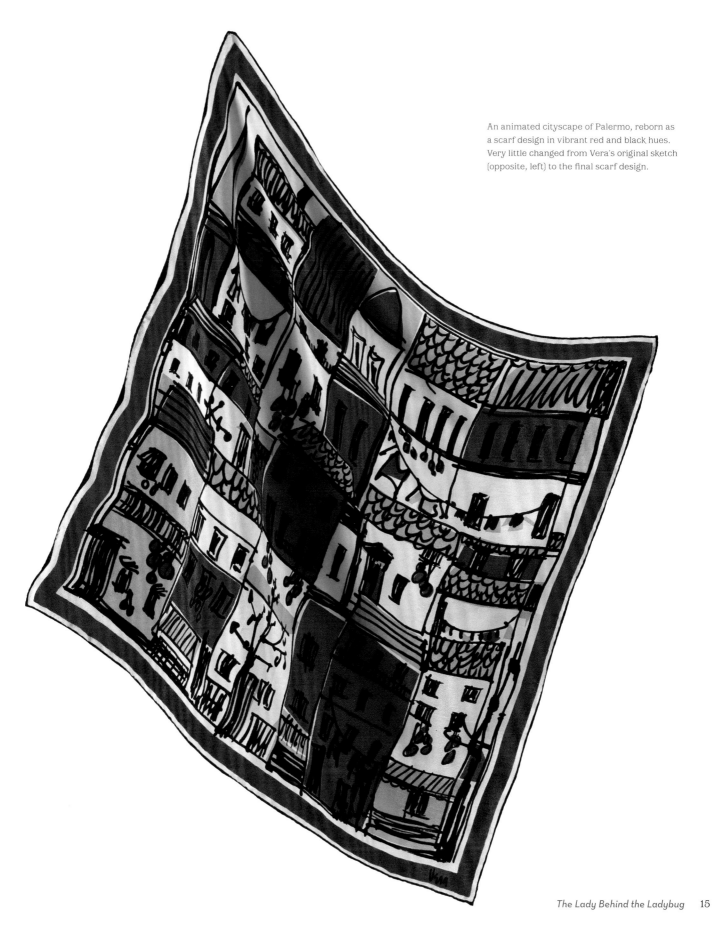

An animated cityscape of Palermo, reborn as a scarf design in vibrant red and black hues. Very little changed from Vera's original sketch (opposite, left) to the final scarf design.

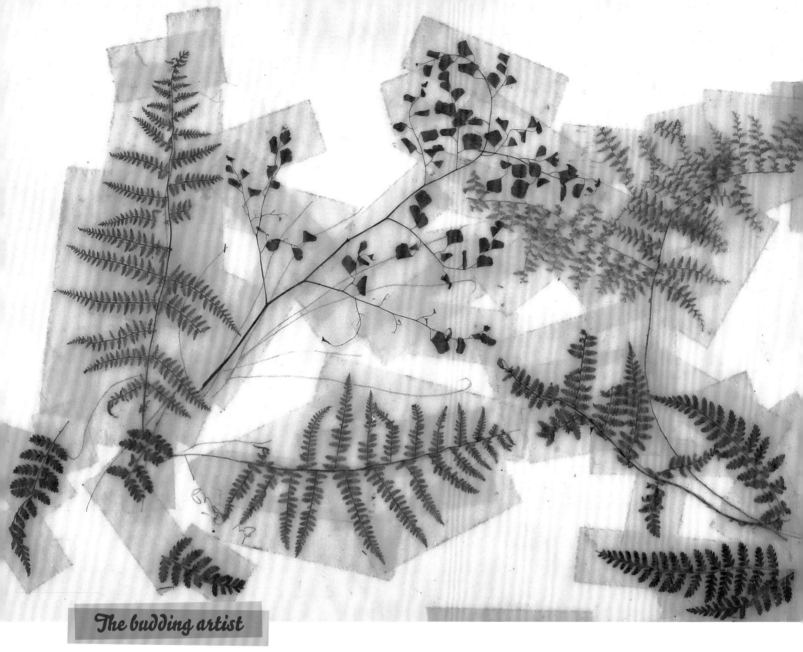

The budding artist

The third of four children, Vera was born to Russian immigrants Fanny and Meyer Salaff on July 24, 1907, in Stamford, Connecticut. Like her older sisters, Grace and Alice, and younger brother, Philip, she was named after the book her mother was reading while pregnant with her—a novel by the Russian feminist, Vera Bashkirtseff (who, incidentally, went by her first name only, too).

Vera was an outdoorsy child who loved nature: exploring it, collecting it, and then rendering it in pen, pencil, or ink. She considered herself an artist from a

very young age. Five-year-old Vera began creating designs with dried flowers gathered near her home and assembling them into collages.[3] "We lived so close to the river, the meadows and woods, and every day as I was passing to and from school, I would pick a fern here and there," she said.[4] Her sister Alice confirmed her younger sibling's obsessions with the brilliant colors and elemental forms that nature offered. "At seven, (Vera drew) fireflies, ferns, the flowers. She has a special love for daisies, and paints

An early collage of dried ferns and pressed leaves. Vera's first artworks as a child comprised similar tableaux, collected from her backyard.

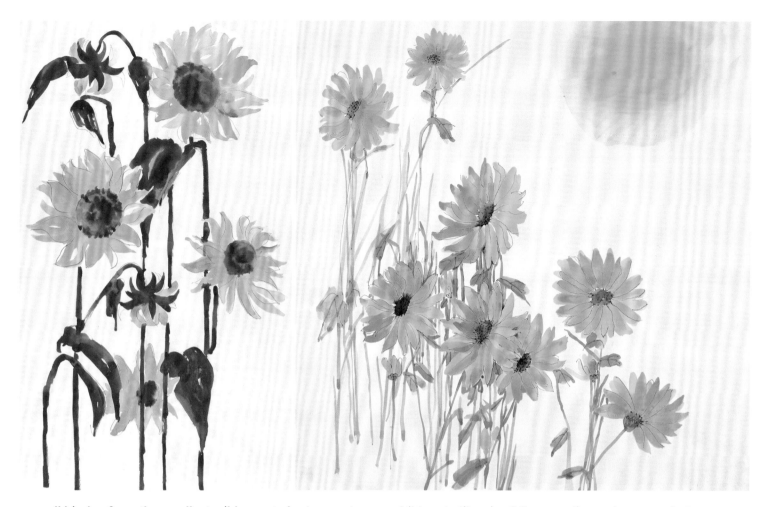

all kinds—from the smallest wild ones to huge orange sunflowers,"[5] she wrote. When recounting her bucolic youth during press interviews, Vera enjoyed painting her younger self in the role of an adventurous wood sprite. A chestnut tree in her backyard was a favorite hangout. "It had tremendous trunks that spread out," she told *The Free Lance-Star* in 1975. "We children each lived in one of those sections, like it was a condominium."[6] For Vera, nature was, virtually, *home.*

Her artistic talent was rewarded early on. Vera's elementary school teacher reportedly assigned her to sketch on the class blackboard. "I'd get up on a stool and draw on the calendar for the month—there were always turkeys for Thanksgiving," Vera recalled.[7] Her father proved a steadfast supporter, too. A coffee and tea importer[8] who dabbled in local politics, Meyer Salaff was also an amateur musician who encouraged his

children to likewise follow creative endeavors, whatever made them happy. "My brother and sisters and I were encouraged—nay, urged—to have passionate interests," said Vera. "Nobody dictated what we were interested in, but we were expected to hang our hopes and dreams on something specific, and to learn all we could about it."[9] In Vera's case, he hired a sign painter in his employ to give her art classes[10] and took her to New York's Metropolitan Museum of Art every Sunday.[11] He even nurtured her budding skills by paying her 50 cents for every sketchbook she filled with doodles. All four Salaff children ultimately chose creative careers. Grace became a singer; Alice, a pianist and children's book author; Philip, an engineer—and Vera, an American design icon.

Young Vera loved all kinds of flowers, but had a fondness for daisies and sunflowers in particular.

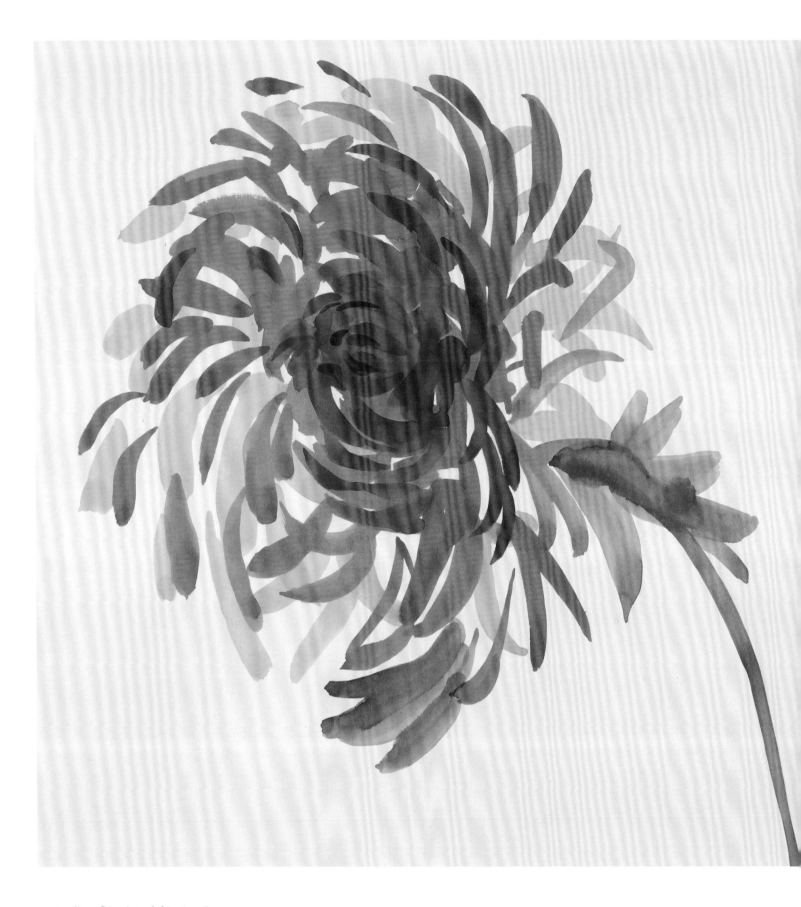

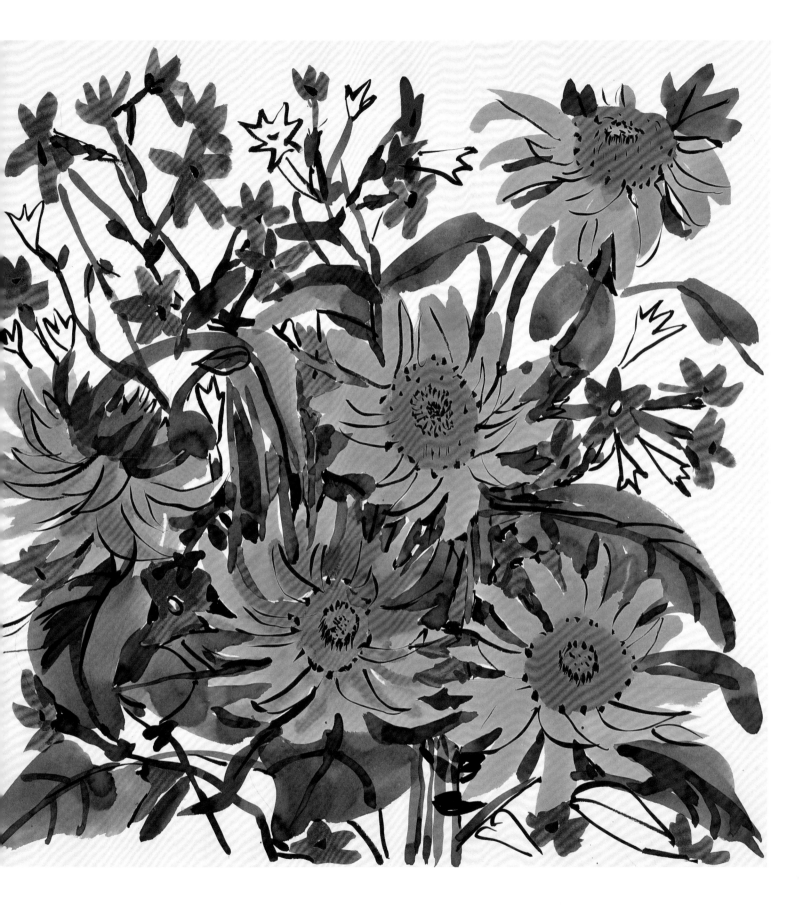

Throughout the 1940s and 50s, Vera often collaborated with her sister Alice, illustrating two children's books with whimsical, impressionistic drawings: Words Are Funny, a volume of riddles, and Sam the Fruit Man, a juicy paean to citrus with rhymes like "Tomatoes are a shiny red, strawberry jam is good on bread." Later, Alice returned the favor by writing the charming aphorisms featured in Vera's promotional materials. "Oh the fun of looking at the summer sun" and "only a flower can understand the language of the rain and snow" are Vera's sentiments, but Alice's poetry.

Sam
the Fruit Man

Pictures
by
Vera Neumann
Words by
Alice Saloff

HARPER & BROTHERS PUBLISHERS
ESTABLISHED 1817

Ripe bananas are good to eat

The melon has many seeds in it

Pears and apples are good for you

Tomatoes are a shiny red

Strawberry jam is good on bread

When you're at Sam's he'll smile and say

A talent blossoms

Vera knew exactly what she wanted to do after high school: attend art school. (No more English classes for her. "I'm OK with a paintbrush, but please, please don't ask me to spell," she once joked to the *Albany Times*.) She attended The Cooper Union for the Advancement of Science and Art, a progressive institution in New York City known for its strong core art program and its commitment to public education. Tuition was (and remains) free for those admitted. Among her contemporaries was painter Lee Krasner (who later married Jackson Pollock). Little documentation about her educational experience exists, save for a comment she made to the *Milwaukee Sentinel* in the 1970s regarding teachers correcting her drawings in black pen.

Vera may have been prone to moments of self doubt—"I'd ask, Should I go on?"[12] she admitted—but she was also headstrong. "No switching majors for me. I (was) single-minded about becoming an artist."[13] After graduating in 1928, on the eve of the Great Depression, she enrolled in life-drawing and illustration classes[14] at Manhattan's famed Traphagen School of Design. An incubator for big-name talents like Mary McFadden and Geoffrey Beene, the institute was founded in the 20s by iconic fashion designer (and fellow Cooper Union alumna) Ethel Traphagen. While the curriculum emphasized the technical and marketing sides of the fashion industry, artistic purity was integral to the dialogue. It was Traphagen who exposed Vera to the tantalizing possibility of a career that bridged fine and commercial art.

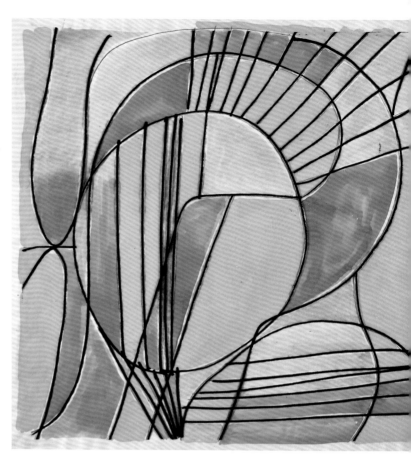

Planting the seeds of a business

Although Vera dreamed of being an artist, she also had a practical streak: "You can't make very much money at it, and anyway I didn't have an attic to paint in, so I had to go out and work."[15] Vera toiled briefly as a fashion illustrator before becoming a textile designer on Seventh Avenue. She experienced her first moment of professional disillusionment when her boss asked her to knock off another company's pattern. "At first, I didn't know what he meant. I thought he wanted me to draw something like it, but he wanted me to *steal* it," she told the *Milwaukee Sentinel*.[16] Such unscrupulous behavior startled Vera, who had a strong moral sense. (She herself never ran out of ideas. "The creative part of the business is like a fountain; it keeps going, going, going. I never repeat myself," she said late in her career.)[17] Soon after, she left to design fabrics and

murals for children's rooms. Freelancing may have been more financially challenging, but it allowed her to stay true to her ideals.

Soon after, she met George Neumann, an advertising executive with a business administration degree from the University of Vienna.[18] He came from a prominent Hungarian[19] textile family and had fled to the United States with his parents in the late 1930s. Vera offered conflicting versions of how they became acquainted. She told one newspaper that they met at a party. To the *Oakland Tribune*, however, Vera revealed that her brother had invited George to their parents' house one day, and that he had asked her out after marveling at the canvases she was painting. Regardless of how their courtship began, she was quickly smitten. "He was handsome, sophisticated, Viennese, and besides knowing about fabric and color and advertising, he had superb taste in everything."[20] (He also drove an Austin-Healey convertible,[21] which may have added to his appeal.) Vera found in George a soul mate who shared her zest for life, and the two quickly became inseparable.

They married in the early 1940s and moved into a small, second-floor studio on 17th Street and Irving Place in Gramercy Park. Vera found the address auspicious after learning that publishing giant Henry Luce was a former resident.[22] Given Vera's creative talent and George's marketing expertise and textile-industry knowledge, embarking on a professional partnership seemed inevitable. "One day, we just decided we ought to work together in some way," Vera said.[23] George encouraged his wife to transfer her bold, expressionistic paintings to fabric, which could then be fashioned into textiles for the home. They hand-built a silk screen just big enough to fit on their dining room table and launched a small printing company, Printex, in 1942. Placemats and napkins were among the few products small enough to produce on the

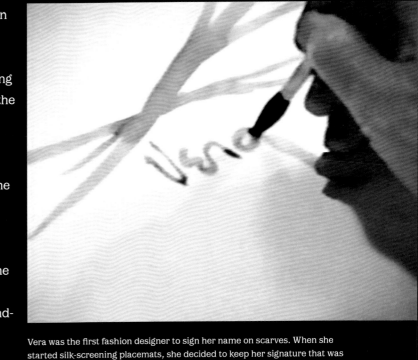

Vera was the first fashion designer to sign her name on scarves. When she started silk-screening placemats, she decided to keep her signature that was on her original paintings.

tiny frame; each piece was printed by hand and cured in the couple's oven. These domestic designs bore a distinctive imprint, Vera's signature, which lent the look of an artist's canvas. "We transferred the design from one of my original paintings, which had my signature on the bottom," she said. "That's how the whole thing started."[24]

The following year the Neumanns were joined by a third partner, Frederick Werner Hamm, a friend in the textile business who had recently emigrated from Germany. A graduate of a textile college in Berlin, Hamm not only understood fabrics, but he also had a canny sales sense. He brokered the company's first order, 1,500 placemats for the New York department store B. Altman & Co. "We couldn't fill it," George explained to the press many years later. "To meet the agreement, we needed $500 in materials and we just didn't have it."[25] B. Altman agreed to a smaller quantity, which Hamm personally delivered to the store.

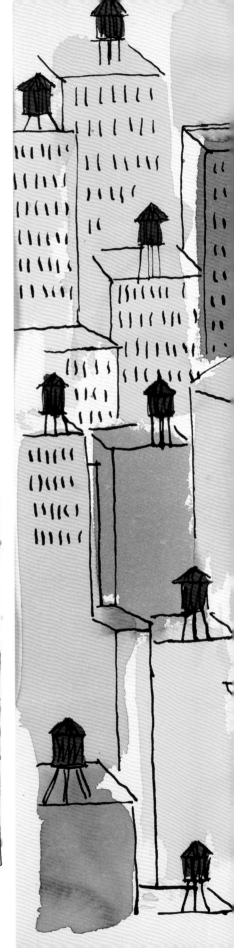

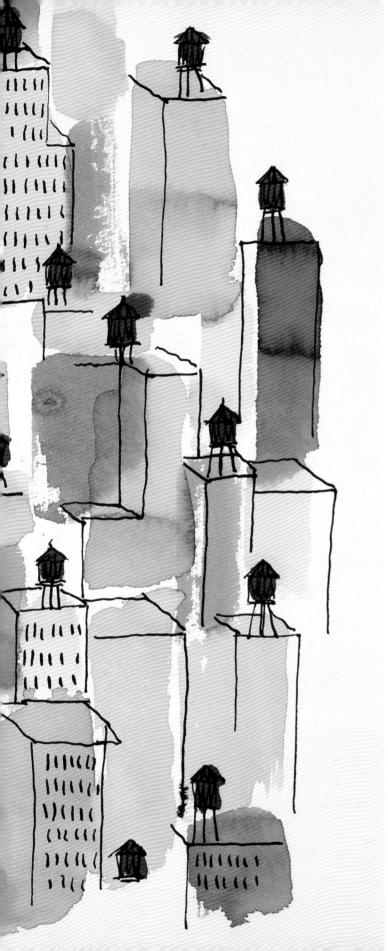

The trio founded the company in 1945, each contributing $1,000. The fledgling label blossomed as orders flowed in. Word of Vera and George Neumann's New York City printing studio spread to René Garrillo, the merchandising director of F. Schumacher & Co. He dropped by to visit one day and was so impressed by Vera's artistry and the company's high production values that he committed to selling as much yardage as the couple could make.[26] Schumacher supplied the fabric—10,000 yards[27]—and Printex executed the screen-printing. Vera's debut line, the Gold Coast collection, was introduced in 1947 and encompassed Asian-inspired prints like her cherry blossom Tibet. It was her first licensing agreement and one of Schumacher's earliest collaborations with an outside designer, a practice they had initiated only the previous decade with couturier Paul Poiret.

The deal inaugurated a decade-long relationship. Vera's patterns were among the company's most popular, alongside those of legendary decorator Dorothy Draper. As archivist Richard E. Slavin III reported in his book with Jane C. Nylander, *Opulent Textiles: The Schumacher Collection*, "No modern design has had the staying power of Vera's glazed cotton chintz Jack-in-the-Pulpit."[28] The pattern, released in 1949, was updated in 1976 when the company reached out to her again. ("The design is good, even if I do say so myself," Vera admitted. "Sometimes I look at things and wonder what ever made me do them, but that one is good."[29]) Jack-in-the-Pulpit remained in continuous production through 1986 and was rereleased in a slightly adapted form in 2000.

The visual rhythm of water towers dotting the New York City skyline caught Vera's eye. She literally refused to paint within the lines, instead applying color-fields beyond the boundaries of objects she had drawn.

Soon, international affairs hampered productivity. Wartime had all but dried up fabric supply for small businesses, forcing them to get creative. One day, as Vera was searching for linen and cotton, she came across excess parachute silk from an army surplus store. She decided to use this as her new canvas. So began her scarf collection. Her first silk-screened design, Fern I, was a silhouette of pressed leaves, akin to a photogram. Success proved immediate. She sold a scarf to retailing giant Lord & Taylor in 1947. The botanical pattern featured a monochrome palette, which was strikingly modern for the time. Like her home textiles, it also bore the name "Vera" on the bottom right-hand corner. This clever element started the signature scarf trend.

An early painting showcases one of Vera's favorite motifs, pressed leaves. Her designs from this period have a tiny signature, but no ladybug. That came later, in the 1950s. Over the years, her signature got bigger and bigger as her name recognition increased.

Vera

A river view

Sales soared as the name "Vera" became synonymous with stylish scarves. Her designs included stylized florals from nosegays to water lilies; abstract color fields; and avant-garde geometrics rendered in unexpected color combinations like lavender and citron or vibrant orange and yellow.

Printex had relocated to a much larger 57th Street loft in 1946 but quickly outgrew that space, too. Vera and George looked farther afield for a new base of command. They found one up the Hudson River, at 34 State Street in Ossining, a derelict 1810 Georgian mansion with a newer addition that once housed a screen-printing plant. The property was a financial stretch. "(It cost) 200 times more than we could afford," George admitted to *The New York Times*.[30] But it was big enough for their expanding enterprise. "It was so rambling," Vera claimed, "that I don't even know how many rooms it had."[31] There were forty, apparently.

A high-ceilinged printing plant overtook the entire ground floor. Above were light-filled studios for the art staff; rows of drafting tables running perpendicular to the window wall enjoyed views of the Hudson River. Four of the mansion's rooms were converted into an apartment for Vera and George: a living area, dining room, bedroom, and painting studio. Period details abounded: stately columns, grand hearths, and wide-plank wood floors graced every room. "We tried to restore all the fireplaces, but it was impossible," Vera admitted. "We did restore all the floors."[32] In the light-dappled interior, white-painted wood paneling formed a neutral backdrop for graphic curtains of Vera's own design. The residence was sparsely appointed in an eclectic mix of folksy finds, clean-lined antiques, and midcentury modernist gems. There was also room for Vera's own studio, where a rolling cart overflowing with art supplies was close at hand. Living above the shop was the very picture of domestic bliss for this creative couple.

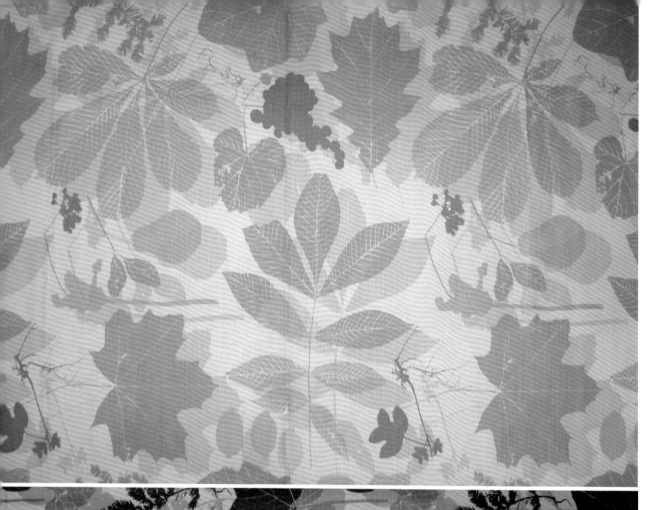

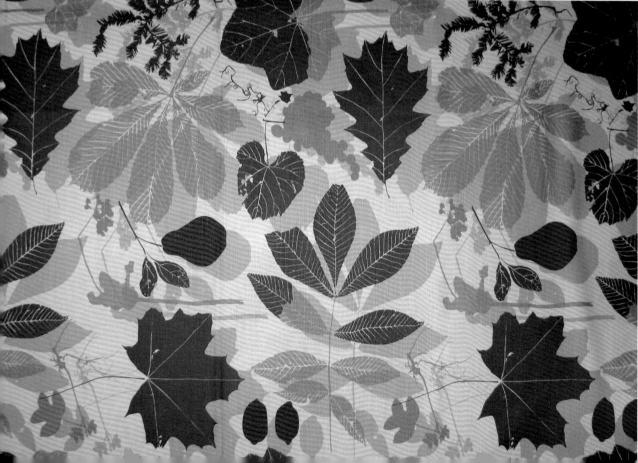

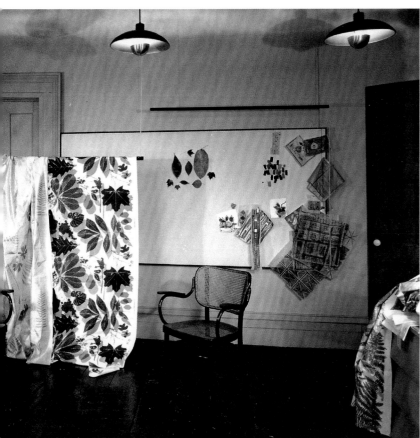

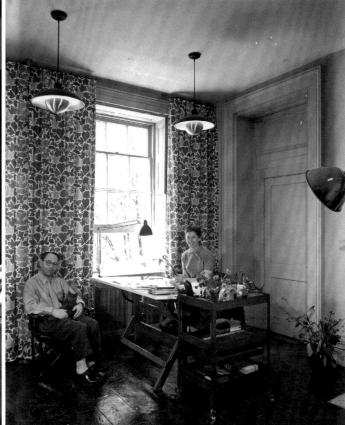

Opposite: Two colorways of Vera's fall 1950 Happy Leaves for Schumacher, hand printed on duck cloth. It sold for $2.25 per yard.

Top, left: Images shot by renowned architectural photographers Samuel Gottscho and William Schleisner for a 1951 *Interiors Magazine* feature depict a series of rooms with wide-plank oak floors and stone fireplaces. In one studio, yards of Vera's Happy Leaves hang from a dowel.

Top, right: Vera and George sit on either side of a drafting desk lit by Verner Panton–like pendant lights.

Right: Ossining's loftlike industrial plant illuminated by an enfilade of fluorescent droplights.

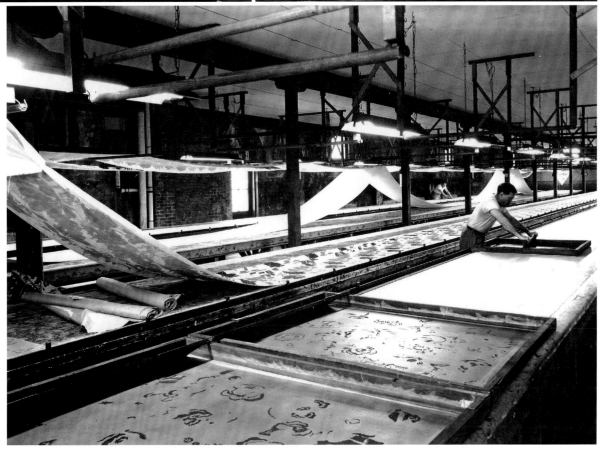

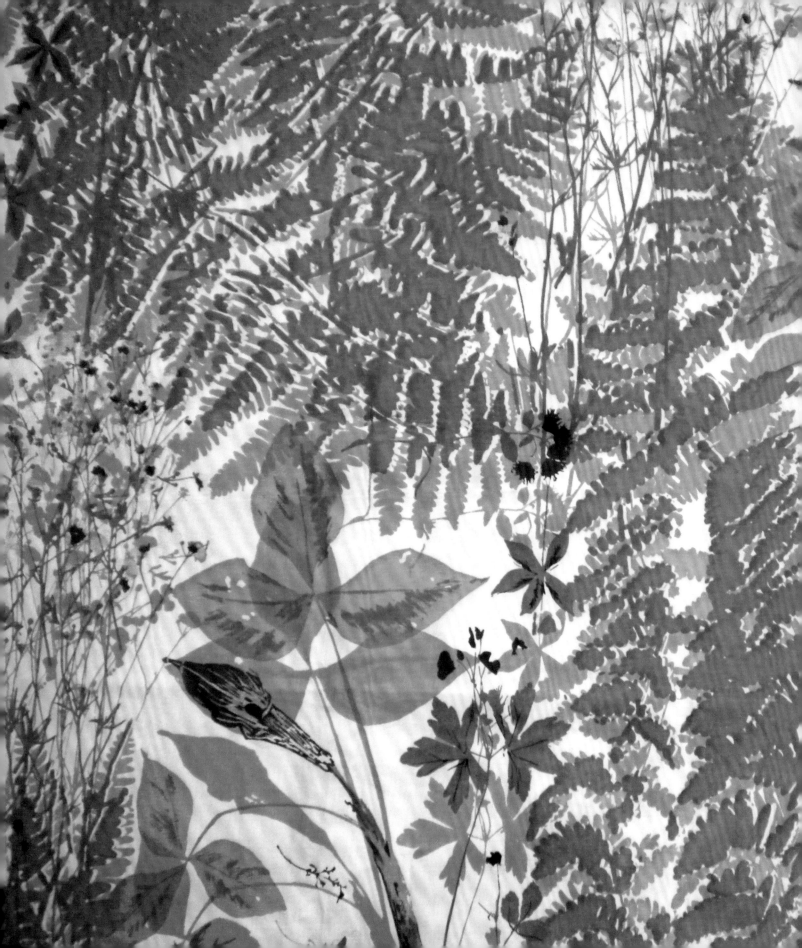

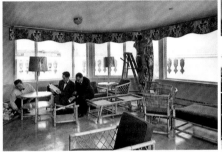

Vera paints a name for herself

With the Ossining plant up and running, creativity and sales flourished. Influential tastemakers took notice of her work. A model wearing Vera smiled from the June 1950 cover of *Harper's Bazaar*. Dame Alicia Markova, the famous Russian-born ballerina, rehearsed in her triangular scarves.[33] Actress Anne Jeffries appeared in a Broadway production of *My Romance* in a bespoke Vera design. First Lady Bess Truman selected Schumacher's Jack-in-the-Pulpit chintz in the brown Mouse colorway for the White House's third-floor solarium in 1952. The lively fern print was installed as a scalloped valance and straight-hung curtains embellishing the wraparound windows. Throw pillows in the same fabric adorned the bamboo chaises below. Who knows how many international dignitaries talked world affairs while surrounded by Vera's restful flora.

Although her textiles hung in the presidential manse and graced the swanlike necks of fashionable ladies, Vera's burgeoning fame was a product of her populist stance. She founded her label on the notion that fine art should be available to all and affordable. "I don't believe only the wealthy deserve good design," she explained. (While scarves by Geoffrey Beene and Pauline Trigère sold for $25 each in 1966, Vera's, in contrast, ranged from $2 to $10.) She disagreed with the notion that fine art should be confined to walls, mounted in gilded frames. Thus, she applied her patterns to humble everyday objects such as aprons and toaster cozies, pot holders, and dish towels. Vera also thought that any subject matter, no matter how quotidian, was fair game, from eyeglasses to musical instruments to chestnuts. In her eyes, even the most mundane imagery had decorative potential. She encouraged her followers to immerse themselves in art every minute of the day and to treat it without preciousness.

Such a democratic attitude set Vera apart from her contemporaries. She entered the industry at a

Opposite: Vera's cotton chintz Jack-in-the-Pulpit cotton for F. Schumacher & Co. features the designer's signature fern print and penchant for offset color blocks, in this case creating the effect that the foliage is casting a shadow.

Above: Jack-in-the-Pulpit was installed in the Truman White House's third-floor solarium in 1952. The pattern, in Mouse colorway, was used for window treatments and throw pillows for seating.

fortuitous time in American history. Although foreign names had dominated the textile-arts scene at the beginning of the century, homegrown talent blossomed as imports slowed in the years between the Depression and World War II. Many of these U.S.-based talents were trained by European émigrés who brought Old World traditions to the States. But in the 1940s and 50s a uniquely American voice emerged that was not derivative of outside influence. A number of women gained recognition in the postwar era, including fabric designer Ruth Adler Schnee, weaver Loja Saarinen, and textile designer Anni Albers, honored with a solo show at the Museum of Modern Art in 1949. But while those designers mostly worked with big-name architects on upscale commercial and residential commissions, Vera set her sights on housewives and young professionals, the masses. "It was a wonderful feeling to see the working girl, as well as a wide audience, taking to our free-form abstract designs," she said.[34]

Vera's designs from this period were often rooted in natural or vernacular sources: expressionistic renderings of flowers collected from the banks of the Hudson, or motifs like Native American folk art. A 1950 article in the *Valley Morning Star* of Harlingen, Texas, surveyed her work through a patriotic postwar lens.

Vera is strictly American . . . She believes that our country offers an endless source of design material. Her current scarf collection takes its inspiration from Colonial America and the Old South. The previous one concentrated on Cape Cod colors, themes, and traditions. For future collections, she plans to draw on historic Mississippi, the colorful west, the traditions of the lumber country of the Northwest—the regional themes to be found throughout the length and breadth of America.[35]

The article goes on to describe Vera painting happily in her studio alongside her constant companions, her long-haired dachshund, Svicki, and Maltese cat, Josie.

While scarves were hand-finished in Puerto Rico, the manufacturing process was otherwise fully integrated under one roof at Printex. This afforded Vera and George the luxury of significant control over the final design, endless finessing of color and line and composition until the desired look of a cotton tablecloth or a silk scarf was achieved. Bauhaus principles, namely industrial processes applied to craft, informed their thinking and their artwork. "Our philosophy was . . . pure design married with pure technology," she said. In a sense, she was "design" and George, who oversaw production, was "technology."

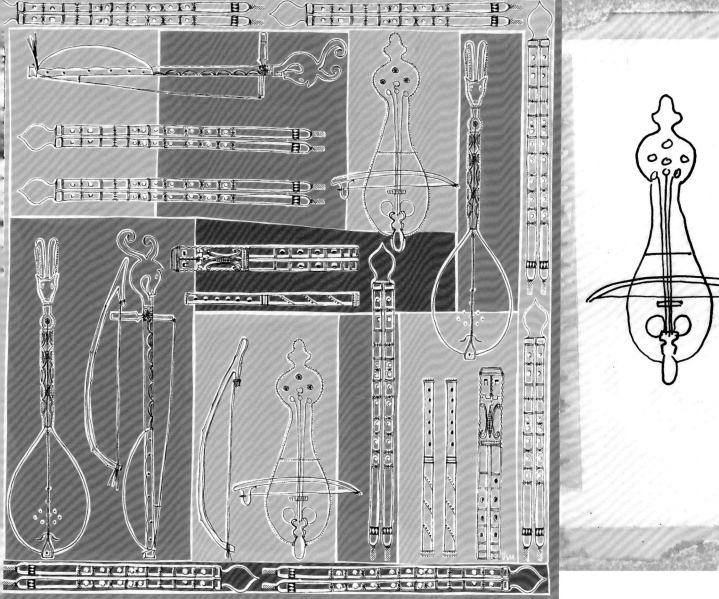

Consolidation of production under one roof also let Vera experiment with small runs and forward-thinking designs, unhampered by commercial constraints. She believed that her consumers had more experimental tastes than the fashion world gave them credit for. Her sales figures bore this out. In accepting the National Home Fashions League's Trailblazer Award in 1972 she said:

Whatever success I have known is because I have always painted up to the public, not down. I have always found the public very sensitive to new trends in the world of art and design. Consciously or subconsciously, they are strongly influenced by the contemporary art scene and welcome so called *avant-garde designs—sometimes long before many professionals.*[36]

By the mid-1950s, Vera had already designed thousands of scarves.[37] Some years later, she added the ladybug to her signature. She felt her name needed a hint of color. "Nature-loving Vera then transformed a jot of vermillion into the ladybug," her company press materials explained. She chose the symbol for its connotations of long life, good luck, and good health, with which she (and her career) would be blessed.

At home and away

As Vera was challenged to create larger and more frequent collections in an ever-expanding roster of categories, she and George began scouring the far corners of the globe in search of visual inspiration to infuse into future collections. They jetted from Asia to Africa, translating those continents' cultures and customs into fashions for women and the home.

But for these citizens of the world, it also became increasingly important to establish a home base. Printex had quickly overtaken the entire Ossining facility. In 1952, the couple purchased property in nearby Groton-on-Hudson, a 15-minute drive away. (Ten minutes, perhaps, in one of the couple's Jaguars; Vera reputedly owned one of only two automatics in the United States.) The 3.5-acre plot was located on Finney Farms, a former apple orchard that had recently been subdivided for residential development. The property was near the peak of a cliff, overlooking the Hudson River. "Getting there required driving up a twisty-windy road—you had to honk your car at every switchback," says her granddaughter, Kimiko Matsuda.

The couple had visionary plans. According to a 1967 article in *Home Furnishing Daily*:

> One Sunday afternoon, they agreed it was time to search for an architect. Where to begin? Their taste was explicit. George Neumann, an Austrian and devotee of the Bauhaus, suggested they start at the top. Marcel Breuer. It was a long shot . . . but their timing was right.[38]

Breuer agreed to take on the commission, perhaps wooed by the couple's own Bauhaus sympathies. He invited Vera and George to his home in Connecticut so they could discuss the program, which would include plenty of space for their expanding brood and art collection.

While traveling, everything from vernacular folk art to a mod hostel in a colorful tent inspired Vera's artworks.

I feel less is more.

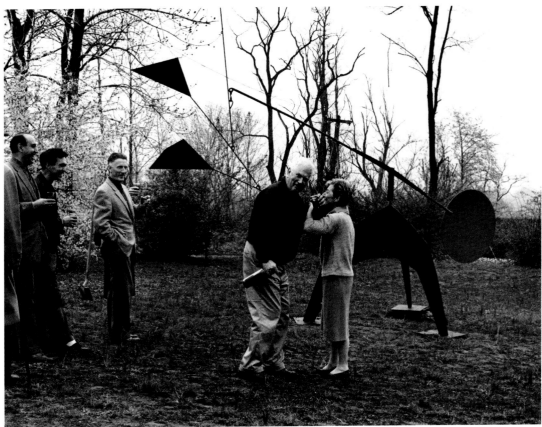

Opposite and left: Among Vera's closest friends was sculptor Alexander Calder, whose artwork she collected. A lively composition of Calder-esque mobiles brighten these scarves.

Above: The installation of Calder's *Constellation* mobile at Vera's Breuer home culminated in a toast.

The project, completed in 1954, featured Breuer's signature clean lines and rigorous simplicity. Perched atop a knoll, the low-slung one-story house had a stone pediment capped by a run of glass that reached up to the flat roof. Like many of Breuer's residential commissions, the exterior was distinguished by invigorating jolts of color. Cinder-block walls were painted red, white, and blue to stand out against the surrounding greenery.

One entered from a flagstone terrace directly into the living room, which was covered in the same material. Two walls were given over to full-height, frameless glass, an engineering feat, to establish a porous boundary between indoors and out. The dining room, which opened off the far end of the living area, overlooked flagstone terraces traced with free-form rubble-stone walls and enlivened with potted geraniums. Furnishings comprised a mélange of mid-century classics, including many of Breuer's own design. Flanking the L-shaped public space were two sleeping wings. One housed the master suite and Vera's studio. The other contained bedrooms for the couple's two children, John and Evelyn.

Breuer later added a cedar-lined pavilion housing an indoor pool in 1973, where Vera swam laps daily. A separate guesthouse farther up the hill, opposite the garage, was also completed at this time. This structure included a suite for George's parents, Lona and Emanuel Neumann, who also lived with the couple. (Of her husband, Vera once said, "I was lucky to get the parents who came with him, too.")[39]

The Neumann's glass box was one of Breuer's favorite houses. His associate, Robert F. Gatje, recalls that Breuer kept a sketch of the floor plan on his wall for many years after its completion.[40] As a result of its avant-garde look (not to mention its celebrity designer and client), the house was equally adored by the design press. *The New York Times, Home Furnishings News,* and the French publication *L'architecture d'aujourd'-hui* were among the many publications that ran splashy features.

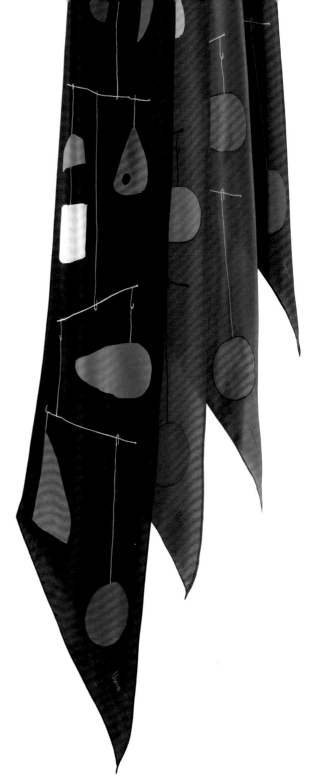

But Finney Farms, as the Neumanns called it, was not just a modernist showpiece, it was a real *home*. Company marketing materials describe Vera living there with her family as well as "innumerable pets, a collection of contemporary art, collections of pressed leaves, seeds, stones, and shells."[41] She frequently entertained and even hosted a wedding there for one of her employees.[42] Work often came home with her in the form of business associates dropping by for meals. "The best nights I ever spent were in Vera's beautiful dining room, with its fireplace and huge glass windows overlooking the Hudson," recalls Gretchen Dale, one of Vera's design directors from the late 70s through 1993. "There was art everywhere—it was really, really contemporary. The food was always beautifully arranged in little jolts of color on very modern white plates." Placed, of course, on the hostess's cheery selection of Vera linens.

Left: A testament to the friendship, one scarf design bore the inscription, "Calder, I love you, Vera."

Right: This elongated neck scarf bears the likeness of a dangling Calder mobile in primary hues. The production strike-off (opposite) shows the final color selection used to guide the printing process.

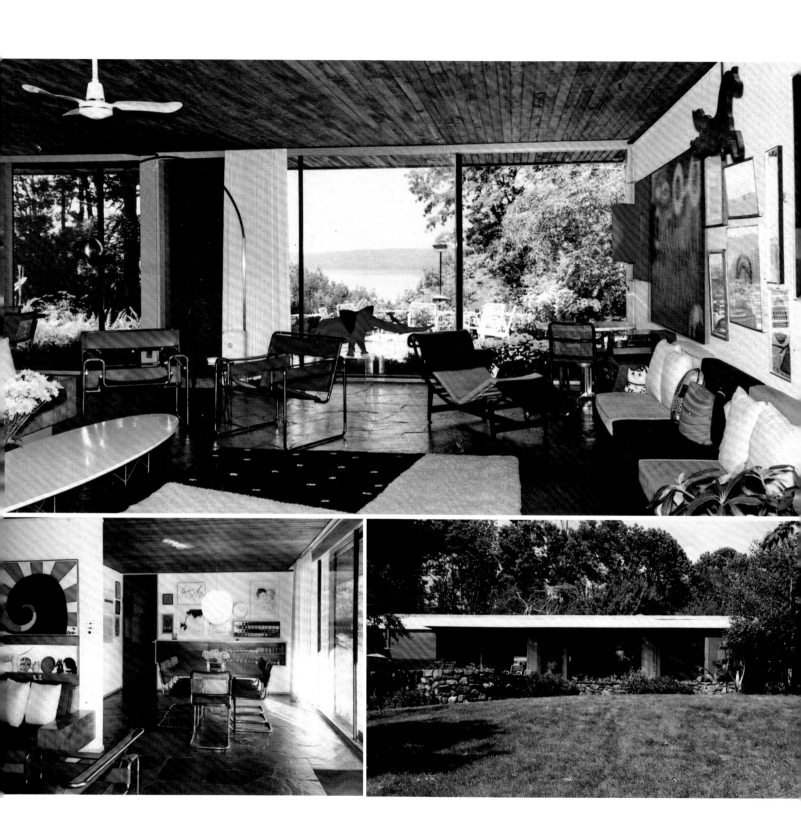

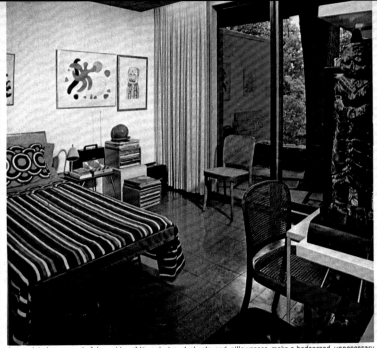

In son John's room, colorful graphics of Vera-designed sheets and pillowcases make a bedspread unnecessary.

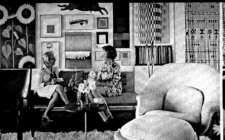
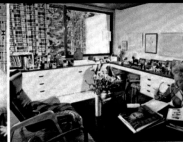

In the living room (above), Vera, in a yellow dress of her own design, chats with a friend. The plywood sculpture, at right above sofa, is by her late husband George. Other works on the wall are also part of Vera's art collection.

Vera, at work in her studio (above), uses the built cabinets for storage and shelf space. Her drapery pr features elevation patterns of the house. The leather ch designed by Breuer, was a gift from the eminent archite

THREE-GENERATION COMPOUND

"Hire the best architect you can afford, even if you can't really afford him at all, and you'll save money on everything." That's Vera Neumann's advice. She's the Vera of fashion-and-linen design fame, in private life the mother of two teen-agers. Home to the Neumann family is a gracious, river-view compound in Croton-on-Hudson, N.Y. "Marcel Breuer designed this perfect three-generation house for us. He provided privacy, independence and togetherness with parents' and children's wings separated and the grandparents' quarters in a pavilion-apartment close by. At first, the idea of so much window area frightened me," says Vera, "but because of the surrounding trees and terrain, we have plenty of privacy. And talk about ease of care! Our unfinished wood ceilings will never need painting."

The flat-roofed main house and connecting garage (right) overlook the Hudson River. Covered walkway in the foreground, far right, leads to the grandparents' apartment next door.

Living room's slate floor (opposite) and white birches contrasting against the red walls of the entry courtyard are Breuerisms. Vera's touch is equally strong—over the fireplace, head-shaped clay vessels survey the room. Sofa at right is a Breuer built-in. Eames and early bentwood chairs reflect Vera's modern-classic taste.

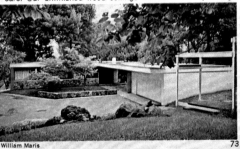

William Maris

73

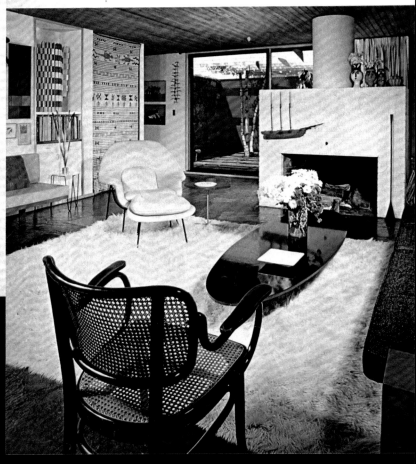

Left: Bauhaus architect Marcel Breuer completed the Neumanns' Croton-on-Hudson home in 1952. Vera lived there until 1981, when she moved into a smaller home closer to her daughter; these images are from the Sotheby's sales brochure.

Right: As featured in an article in *American Home* magazine in 1970, the open-plan living spaces were furnished with blue-chip artworks and midcentury modern classics and included bedrooms for the couple's two children as well as George's parents, who lived with the couple.

Vera relaxes with two of her many dogs below a painting of sunflowers by her father-in-law that hung in her living room.

The interior featured a covetable array of blue-chip paintings, sculptures, and works on paper; Vera and George often gave each other artwork for their birthdays. A Max Bill sculpture on a granite pedestal greeted visitors at the entry. A Pablo Picasso crayon on paper hung in her bathroom,[43] perhaps as a reminder that great art should never be treated too seriously. The living room beyond was covered in a salon-style collage of adventurous Cubist works by Georges Braque, op-art color-fields by Josef Albers and Victor Vasarely, and modernist masterpieces by Henri Matisse, Oskar Kokoschka, and Rufino Tamayo. Highlights included a drawing by Italian product designer Enzo Mari and a 1964 deluxe edition of Joan Miró's *Quelques Fleurs pour des Amis,* inscribed by the artist: "Pour Vera Neumann, hommage de Miró."[44] Interspersed among these were works by her family, including her son and father-in-law, who had taken up painting at the age of 80. A plywood sculpture by George hung by the sofa. (One person whose art was notably absent was Vera's.)

The most famous piece in the couple's collection enlivened the backyard: Alexander Calder's mobile *Constellation* of 1960. Vera counted the artist as one of her closest confidants. She was often bedecked in his sculptural brass brooches, and their friendship even inspired three scarf designs, one signed, "Calder, I love you, Vera." *Constellation* was given as a gift on November 16, 1961. Legend has it that Calder rang Vera to warn her that he was coming over with a present. The artist arrived toting not a small tabletop piece, as she had expected, but a 14½-foot-tall mobile, a red circle counterbalancing four black-painted metal triangles. She and George insisted on paying him several hundred dollars, even though it was intended as a gift. A photograph from the installation shows Calder and Vera on the lawn, arms intertwined, making a toast. "Inside, the walls were jam-packed with amazing art— but you couldn't take your eyes off that view of the Hudson and the Calder," says Kimiko Matsuda.

Vera owned more diminutive Calders, too: a small blue elephant stabile with moveable ears and a *Sun* that brightened her lawn. Most personal, though, was a thank-you note, a watercolor sketch of a giraffe, which the artist delivered rolled up inside a paper towel tube. Vera had given Calder a gift as well. "Vera, thanks for the towels," he wrote. She had it framed.

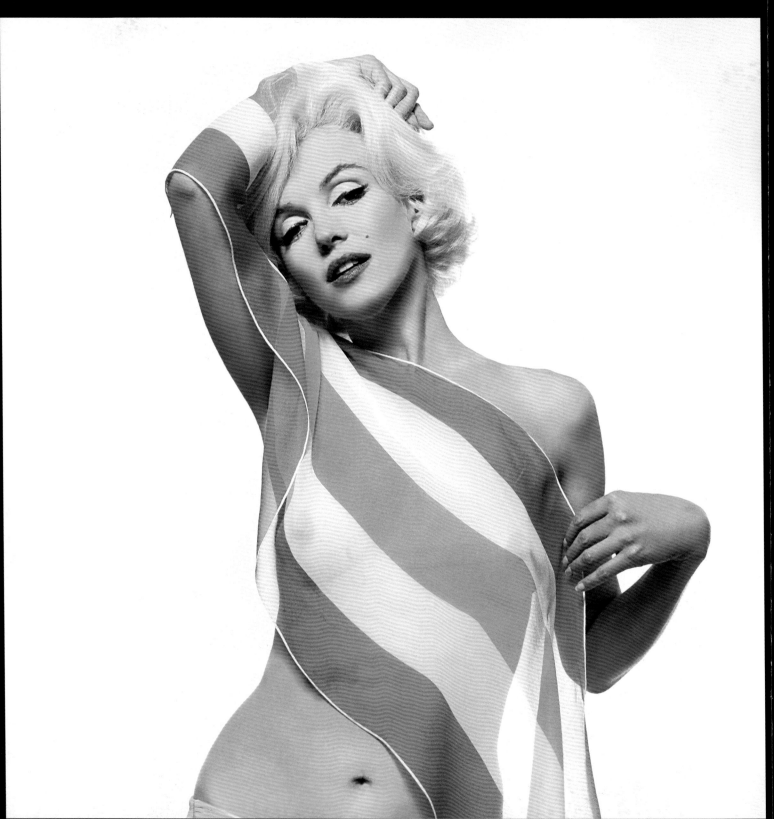

Vera's empire expanded in the 60s, perhaps her most prolific decade. After securing her reputation as the country's top scarf designer, employing a staff of 200[45] to envision and produce 130 patterns per season, she launched Vera Sportswear in 1960. One day she tied together the corners of two scarves, fashioning them into a makeshift blouse. Voilà, the Jollytop—and her clothing collection—was born. A full-fledged sportswear line developed from there, her offerings expanding into tunics, dresses, pants, outerwear, and, eventually, "innerwear." ("The word 'lingerie' just isn't right," she admonished.) Vera even dreamed up a line of terry-cloth outfits bearing jaunty butterfly, fish, and sun prints billed as "wearable" towels. They were inspired, she explained, by her son's and daughter's wet feet padding around the house after a swim in their Breuer-designed pool house. Why not combine two functions in one, and dry off and get dressed at the same time? Up-and-coming actress Jane Fonda modeled one of the beach ponchos in the pages of *Parade* magazine.[46]

Stylish Vera was her label's best advertisement, her petite five-foot frame clad in mod shifts, always accessorized with an op-art scarf. Her jewelry was bold too. She would slip on one of her sculptural Calder brooches or a folksy cluster of Native American squash-blossom necklaces. A fashion writer for *The Washington Post* approvingly noted her blue-framed glasses and predilection for Halston Ultrasuede dresses. ("She likes the big, loose slouch look in fashion but complains they make her look 'like a little squirt.'")[47] She was photographed for the newspaper with her broken right arm in a sling made from a knotted silk Vera scarf, fashionable even under duress. "I never saw Vera dressed casually," said Joan Reil, who worked with her from 1981 to 1988,

Vera clings to a star: a photograph from Bert Stern's "The Last Sitting" series, 1962.

eventually becoming creative director of scarves and linens. "She always wore dark pants, a colored tunic, a scarf, and bold jewelry."

"It" girls fell for Vera. Marilyn Monroe, for one, amassed a trove of her scarves, which sold at Christie's 1999 auction of her estate.[48] Fashion photographer Bert Stern snapped the sexy startlet wearing nothing but a sheer yellow and orange Vera scarf in her final photo shoot, the infamous "Last Sitting" series taken at the Hotel Bel-Air six weeks before her death in 1962.

That same year, Vera experienced a personal tragedy of her own. Her beloved George died of a heart attack in New York on January 3, 1962. It was a devastating shock to the family. Although Vera's time with her husband was cut tragically short, George's spirit, kindness, and vision continued to guide her. "George had such a wonderful, far-reaching goal. He saw so many things I never visualized," she said.[49] Vera stayed true to his exacting aesthetic. She was insistent that her business success was very much a product of her own doing, while crediting her husband with the support and love necessary to achieve it: "I would have made it without him. Sure. I would have made it. (But) everybody needs a George."[50] Her brother, Philip Salaff, an engineer, took over George's role at the company.

Vera honored George's legacy by catapulting the company to almost unfathomable heights. By 1966, her scarves retailed in 10,000 stores in North America alone.[51] That year, annual sales soared to $12 million. Accounting for half that volume was sportswear,[52] which was marketed in a sleek showroom designed by Marcel Breuer. Even after George's death, the couple's partnership allowed Vera to realize her loftiest artistic ambitions.

To better support their expanding brands, Vera and Werner Hamm sold the company to Manhattan

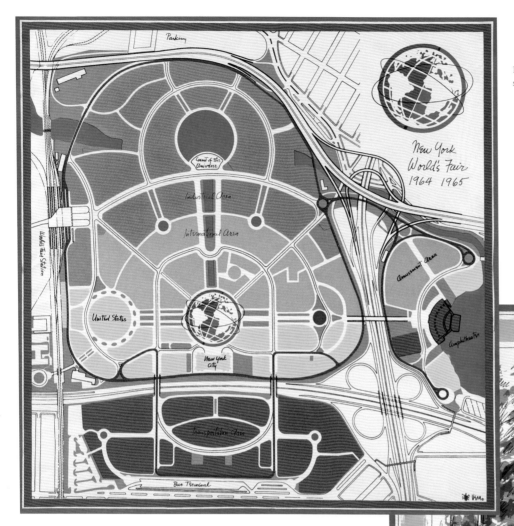

In 1964, Vera was invited to design commemorative scarves for the New York World's Fair.

Industries for $5 million in 1967.[53] Both became board members, and Vera remained the creative director. The influx of capital allowed them to double the size of the Printex plant and branch into new categories like luggage, a subject close to the world traveler's heart. Her lightweight canvas suitcases, which debuted at B. Altman in the fall of 1969, included a bonus bag in an inside pocket, an extra carryall for jet-setters to tote home souvenirs. They came in handy for Vera's own journeys, as she flew to exotic locales two or three times a year to get inspired. And, perhaps, to preserve the memory of her devoted travel companion, George.

The artist and her atelier

Some thirty years after launching her business on a tiny silk screen in a cramped studio apartment, Vera had established herself as a household name. Indeed, a survey conducted around this time concluded that her name was even more recognizable than Grace Kelly's.[54] By 1972, her scarves were showcased in 20,000 stores around the world, from Lord & Taylor and Bonwit Teller, to Bloomingdale's and Joske's. She was the most prominent female entrepreneur of her time with the first true lifestyle brand; she was a polymath with licensed goods including twice-annual bedding collections for Burlington (alongside fellow icons Laura Ashley and Pierre Cardin), needlepoint pillows for Dritz-Scovill, and china manufactured by Mikasa and Island Worcester. A cross-marketing genius, Vera encouraged her licensees to create goods featuring certain patterns to create the effect of a coordinating product line that bridged categories.

To meet the daunting demand of designing everything from calendar towels to crewel kits, Vera employed a staff of twenty-five artists in her Ossining studio.[55] Vera's granddaughter Kimiko Matsuda, who worked at the studio during high school, remembers being dazzled by the racks of colored markers that filled the space. "The artists had them in every color under the sun. It was like being a kid in the candy store."

Vera doted on her artists. "She had tremendous respect for the people in her art studio, as well as for the creative directors who worked for her," says Joan Reil. "Vera mentored us. She had a funny sense of humor, very sharp, yet also very gentle. But when she disapproved of something, she could also give you a look—just like a parent."

She nurtured her artists' creativity by giving them one day off each month to visit museums for inspiration. Not that there wasn't plenty of inspiration within

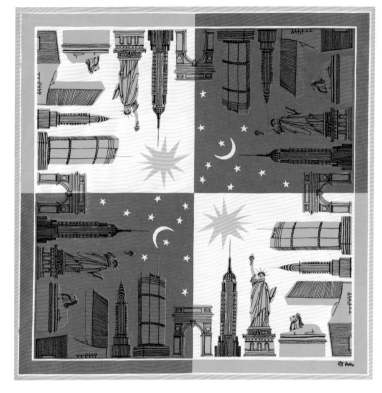

The Statue of Liberty, the Chrysler Building, and the U.N. Tower are among the architectural icons depicted in this New York City–themed scarf. Even Vera's more iconographic compositions bore an abstract quality.

a few feet of their desks. Vera had amassed an enormous folk art collection during her travels. Most of the items were displayed at the studio while others were kept at home. Her holdings comprised objects as diverse as cookie tins from Taiwan, looms from Lapland, African war masks, and a Yugoslavian cake smuggled home on the plane (which required sweet-talking a customs agent).[56] Vera lined the sprawling Ossining facility's hallways and walls with bookshelves filled chockablock with global curios, creating a sort of ad hoc museum. Says Gretchen Dale, "Folk art was part of how Vera thought." It was also how she taught her artists. "I've always wanted to have a folk art school," said Vera. "One where old masters teach the young embroidery, carving, woodwork, calligraphy— skills that are becoming extinct," and the ones whose effects she captured in her designs.

Vera paints

Curatorial skills aside, Vera's commercial success was indebted to a canny marketing scheme that promoted her as the gifted fine artist that she was. Her collections were billed on promotional posters as "paintings, printings, and limited editions." She called her showrooms the Vera Galleries. Company promotional materials explained that, "When completed, designs are registered in the Library of Congress as a work of art. And then it will be interpreted in fashions for you to wear and to use." Posters and advertisements promoting her seasonal collections depicted Vera leaning intently over her watercolors, brush in hand and a long-haired dachshund or two in her lap. Many such ads featured the tagline "Vera paints," an ongoing campaign. Every season would feature a new theme, from "Vera paints a bunch" (clusters of carrots) to "Vera paints suns," a motif the luminous Leo included in every collection.

The 1970s marked a period of artistic recognition for Vera. "She was a very savvy business woman *and* an artist. That is a rare combination," says Gretchen Dale.

She was the subject of numerous museum and gallery exhibitions, starting with a 1970 show at the Emile Walter Galleries, located at 121 East 57th Street. A celebration of her 25th year in business, it featured some 50 original artworks showcased against a backdrop of gauze panels. Her first customer? John Lennon, who purchased a painting of a cube. Joan Crawford and Arlene Francis both bought likenesses of fruit.[57]

The event spawned a traveling retrospective, "25 Years of Vera Original Paintings," that toured department stores across the United States, from the Bon Marché in Seattle to Macy's in New York, which played host in November 1974.[58] She displayed pieces in boutique environments mimicking art galleries, with canvases propped on easels and hung on the walls, next to scarves backed with foam core to look like paintings.

Most prestigiously, the Smithsonian invited Vera to inaugurate its Resident Associate Program in October 1972. Subsequent artists included Willem de Kooning, Georgia

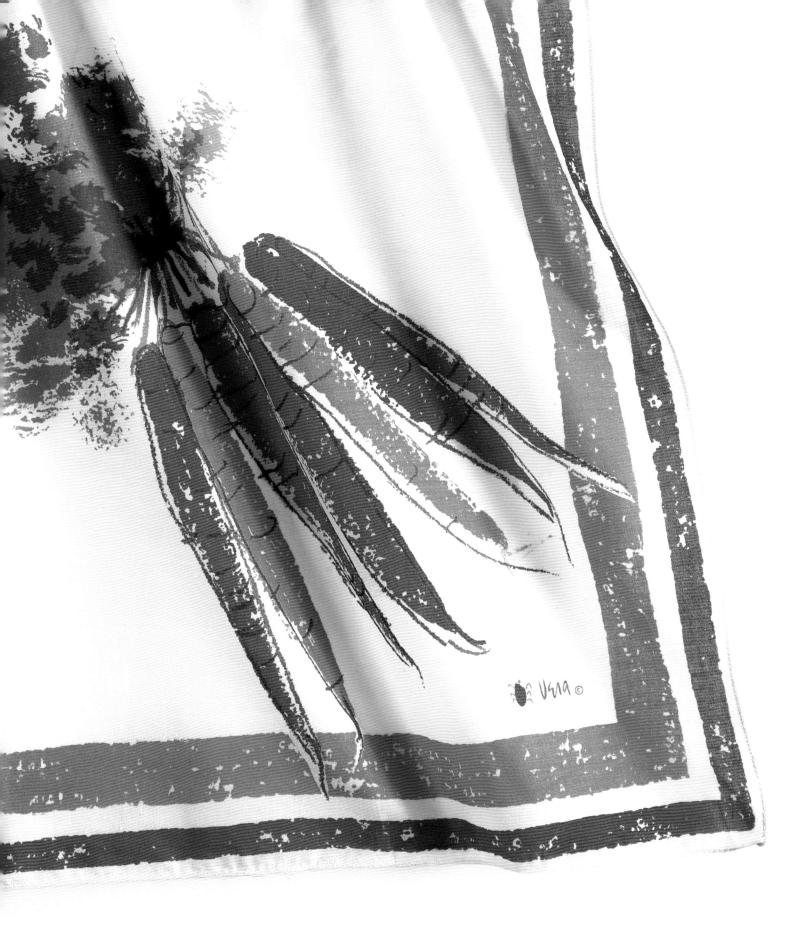

PLATES MADE
TABLE CLOTH
BLOUSE

Below: Macy's commissioned Vera in 1976 to create a painting (right) for store shopping bags, to commemorate its annual flower show in San Francisco.

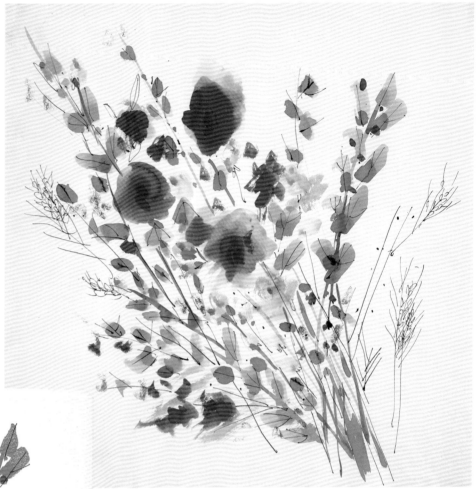

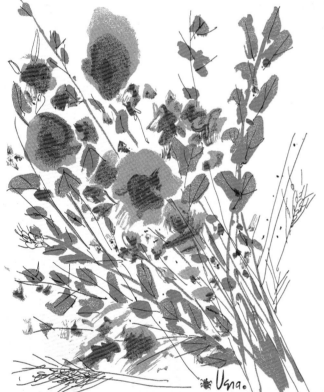

macys
30th ANNUAL EASTER FLOWER SHOW
San Francisco April 11-17

O'Keeffe, and Vera's good friend, Alexander Calder. The scope of the residency entailed a commissioned piece, her iconic *The Foucault Pendulum*, based on the Smithsonian's popular tourist attraction. The museum turned the artwork into a scarf and a poster sold in an edition of 500 to benefit local scholarship programs. The residency culminated in "A Salute to Vera: The Renaissance Woman," a ninety-minute multimedia presentation at the Museum of History and Technology. Slides, films, and models of Vera's work, with a taped narration by Marcel Breuer,[59] gave audience members an overview of her illustrious and diverse output. Following was a dinner sponsored by the Washington Fashion Group. Lucky attendees took home a Vera silk scarf and their Vera-designed dinner napkins, too. "People always take them anyway," she joked.[60]

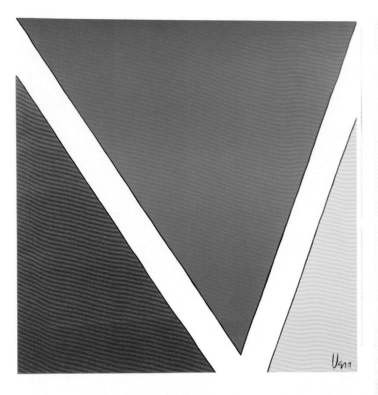

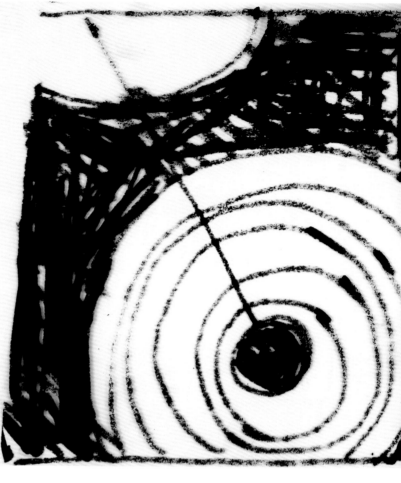

Vera | retrospective 1945–1970

Emile Walter Galleries, 121 East 57 Street, New York, March 31 to April 4, 1970/from : 10 am to 6 pm

Top left: Vera's first art exhibition, a retrospective to honor her 25th year in business, was held at Manhattan's Emile Walter Galleries in 1970. Proceeds from the sale of this limited-edition poster were donated to the Fashion Institute of Technology.

Top right and opposite: The poster (opposite) and sketch (above right) depicting Vera's *Foucault Pendulum*, an artwork commissioned by the Smithsonian's Resident Associate Program in 1972.

Overleaf: A poster from the Philadelphia College of Textiles and Science's 1980 Vera retrospective, mounted at the school's Goldie Paley Design Center.

In 1975, the Fashion Institute of Technology's museum mounted its own Vera retrospective, "Vera: The Artist in Industry 1945–1975," which included 67 original paintings, 28 posters, and four limited-edition silk-screen prints that sold for $100 each, with proceeds donated to the school. Five years later, the Goldie Paley Design Center at the Philadelphia College of Textiles and Science repeated the honor with "Celebrate the Seasons of the Sun With Vera." Curator Leanna Lee-Whitman wrote in the exhibition brochure, "Vera's creativity springs from a deep reservoir of happiness and fulfillment." Talk about fulfillment; that year, she received two honorary degrees, a doctorate from the Philadelphia College of Textiles and Science and a citation from her alma mater, Cooper Union.

Vera.

The Foucault Pendulum Smithsonian Institution

Celebrate the Seasons of the Sun — Vera

In 1977, Vera's empire charted $100 million in annual sales. Four years later, she was featured in Lois Rich-McCoy's *Millionairess: Self-Made Women of America*, alongside architect Beverly Williams and Jean Rich, president of Rich International Airways. The world knew Vera as one of the most decorated and respected entrepreneurs of the time. Those who worked beside her, however, remained struck by her unwavering humility. "With that level of success, some people get a head on them," says Gretchen Dale. "But she was always very humble." Nancy Kristoff, president of Bardwil Linens, has similar recollections (her first job was in linen sales for Vera). "Vera was so well-traveled and had a fascinating life experience. Yet she was totally down-to-earth. I always remember her ordering half a tuna sandwich from Mary Elizabeth deli down the street for lunch; she was just so *regular*."

She was also quite shy. "She always needed a New Yorker around her; one of us would always have an arm at press events," says Joan Reil. Dale remembers one Burlington press event in particular. "I looked over to see Vera and Laura Ashley chatting by themselves in the corner, just having the best time. Mingling was not her thing."

Vera's success had created an enormous market for decorative scarves; to stay competitive in a diversifying marketplace the company began manufacturing products targeting other audience groups and aesthetic sensibilities. Vera Industries became the licensee of Perry Ellis, Anne Klein, and Vicky Davis neckwear. In 1984, the brand targeted a younger demographic by launching its funkier, less expensive Acute line.[61] It was a prescient move; tastes were starting to shift, both in fashion and in housewares. By the mid-80s, traditional chintzes and cabbage roses were all the rage in home design. "The super-traditional Mario Buatta

look really took hold, and contemporary was out," explains Dale, director of table linens and licensing during that transitional time. "But Vera always stayed true to her vision. She wasn't about to be a follower. Simple and plain was her cup of tea." Times were changing, but the company was still doing $50 million at wholesale in 1984.

She continued to embrace new challenges. At a time when Vera could have rested on her laurels, she remained highly selective, and had no interest in simply stamping her name onto an ever-expanding portfolio of consumer goods. Dale recalls Crown Zellerbach approaching the company to design graphics for Kleenex boxes. "Vera said, 'Gretchen, I'm not sure what I can add to that product category.' So we drove to the grocery store and realized there was nothing out there except bland pastels. There was a lot of room for improvement." Customers soon snapped up Vera-designed boxes bedecked with meadow ferns and butterfly prints.

Botanical artist Wendy Hollender remembers working on the Vera bedding account as a young stylist at Burlington Industries in the early 80s. "We produced two collections a year; the Rainbow Butterfly pattern was a really big hit while I was there," Hollender remembers. She was one of a team that helped translate Vera's original paintings into repeats for bedding. "We would go up to Ossining to pick out artwork. I was quite junior, so (I) spent a lot of my time observing. By that point, Vera was more hands-off—she had been working with Burlington for more than a decade and really trusted us—but she still painted her own artwork. I remember walking into her office one spring day, right when the dogwoods were blooming. She had a branch on her desk and did a quick sketch. She made it look so easy, that combination of color and line and

design and realism. She was very creative in so many different ways: You might know her for her florals, but her geometrics were amazing, too."

Although she still commuted to New York City every Tuesday, Vera devoted more and more time to her family. In 1981, she sold her iconic Breuer house and moved into a smaller home near her daughter, Evelyn, and two grandsons. John and his children lived nearby, too. "We had an arty childhood," says Kimiko Matsuda. "I spent lots of time drawing and coloring, and working on paper crafts in her studio. She or my uncle Phil would make a scribble on a piece of paper and we'd have to turn it into an object." Still, Vera never pressured her grandchildren to join the business; as her own parents did with her, she encouraged them to follow their own tune. "She'd say, 'I'd rather you go create your own adventures, explore and experience your own stuff.' I can't express what a brilliant inspiration she was to each of us in our own way." Kimiko ultimately spent summers and school breaks working in the studio and showroom.

Fashion writer Ruth La Ferla reported in a 1985 *Dallas Morning News* article that Vera, then in her mid-70s, "rises each day at 7 A.M. and packs her four grandchildren off to school. By 8:30 she is busily immersed in the development of one of the more than 500 new motifs she creates each year." Vera, "Nanny"

to her grandkids, averred that she was painting a little less frequently. "I'm taken up with my whole new life, which is my grandchildren. I would say that by the time I'm 100, I might have time (again) to paint."[62] But she insisted that retirement held zero interest. "I'll never stop working. They'll have to carry me out," she joked. "I'll die in my chair at the studio."[63]

One thing Vera disliked was the emergence of computer-aided printing, which was anathema to her hands-on, artisanal process. Says Dale, "We were at a trade show in the early 80s, when the CAD (computer-aided design) machines came out. She recoiled and said something like, 'That just loses the spirit of what it's all about.'" As the industry evolved into a more mechanized and mass-marketed operation, Vera remained devoted to hand-craftsmanship and basing her designs on an original work. She may have been traveling a bit less, but she continued to find abundant sources of inspiration. In 1987, the Museum of American Folk Art invited her to peruse its permanent collection for quilts to adapt into scarf designs. The five scarves, which retailed for $30 at the museum's 50th Street boutique, included Bird of Paradise, Double Wedding Ring, Lone Star, and Tumbling Blocks patterns, as well as one based on a 19th-century board game.[64]

In April 1988, Manhattan Industries was purchased by private apparel producer Salant Corporation in a hostile takeover. Although Vera remained the head designer, the Ossining plant was closed later that year. Thousands of original artworks, scarf designs, and an archive of products created over four decades were placed in storage. Some 228 pieces of her folk art collection, including Peruvian saddle blankets and Yugoslavian belts, were donated to the Kent State University Museum, where she hoped they would be accessible to a broader audience.

Vera's legacy

"As you are getting older, you're losing the fluff along the way."—Vera [65]

Although The Vera Companies had begun licensing out its sportswear division in the early 90s, it was still producing scarves and linens when Vera passed away on June 15, 1993, just shy of her 86th birthday. She died of cardiac arrest following surgery at Phelps Memorial Hospital in North Tarrytown, New York, south of Ossining. She still painted and contributed designs to her collection up until a few months before falling ill. Her extended family—children, grandkids, siblings, and staffers past and present—were devastated. "She created such a unique and special atmosphere," says Joan Reil. "People were very loyal. It was a great company to work for. We all felt such a loss when she died."

The memorial service was held at a private home in Ossining. "It was a really neat funeral—truly a celebration," Gretchen Dale recalls. "She had such a happy and fruitful life, and shared that joy with so many others." The optimistic tone was a fitting tribute to an American icon whose designs had brought a smile to so many faces during her half-century career.

Masterpieces from Vera's art collection, including works on paper by Picasso, Miró, and Mari, were auctioned off that fall. Her Calder *Constellation* was the highlight of the Sotheby's November 10, 1993, Contemporary Art I sale. It fetched more than double its high estimate of $700,000. According to the *International Herald Tribune*:

> Within 10 minutes, Constellation *became the night's sensation. It was acquired from the artist in 1961 by Vera Neumann, who died this year. So much history proved more than the equanimity of art lovers could withstand. The mobile moved up to*

a world record $1.8 million and the room broke out in thunderous applause. [66]

The list of honors Vera received over the course of her lifetime was lengthy and included awards from the Art Directors Club, the American Institute of Decorators, the American Printed Fabrics Council, the National Home Fashions League, and the U.S. Industrial Film Festival, as well as numerous Coty Awards. Just as lengthy was the roster of causes she supported, from global charities to local scholarships. For many years Vera had sponsored work-study programs for textile-design students and established a scholarship fund at Ossining High School for the artistically gifted. [67]

Even after her death, Vera enjoyed continued critical recognition and stayed in the spotlight. In 1996, the Metropolitan Museum of Art's Costume Institute acquired a Vera scarf for its permanent collection: a design featuring torn newspaper titles (*Le Figaro, El Universal*) against a bright-yellow background. A pair of shows in 2000 contextualized her work among her contemporaries. She was one of 221 female artists whose work was exhibited in "Women Designers in the USA, 1900–2000: Diversity and Difference" at New York's Bard Graduate Center for Studies in the Decorative Arts, Design, and Culture. The piece that was shown, Papaya, a 1952 F. Schumacher & Co. textile design featuring brown and orange leaves, epitomized the canny fusion of authenticity and abstraction for which she was renowned. Vera was also one of forty female textile artists showcased in the Fashion Institute of Technology museum's companion show, "A Woman's Hand: Designing Textiles in America, 1945–1969." The exhibition featured two scarves donated by a private collector alongside Happy Leaves, a 1950 F. Schumacher & Co. pattern.

More recently, highlights from the Kent State University Museum's Vera Neumann Collection, including a 20th-century embroidered Moroccan vest and a pair of stuffed Pakistani cows with metallic stitching, appeared in "The Art of the Embroiderer," which ran through December 2009.

As the vogue for midcentury modernism reached a fever pitch over the last decade, Vera's business has taken on a new life. The brand has been revived by a new owner, Susan Seid, who in 2005 purchased the design assets and trademarks from the Tog Shop, the catalog company that had acquired The Vera Companies from Salant Corporation in the late 1990s. In addition to organizing the extensive archives of scarves and copyrights, The Vera Company (as it is now known) has partnered with new licensees to produce contemporary apparel and home fashions featuring the artist's historic patterns.

Vera remains a media darling. Her scarves have been worn by characters in the movie *Confessions of a Shopaholic* and on the small screen in *Gossip Girl,* the *Today* show, and *The Tyra Banks Show.* Her collector base has proved both passionate and diverse, and her scarves, blouses, and housewares are hot-ticket items on eBay and Etsy and in vintage stores around the world. While many women who came of age in the 1960s and 70s remember Vera from her heyday, a younger audience has become intrigued by the spirited one-name signature and her timeless designs.

No one could have summed up her legacy better than the designer herself: "Vera will be Vera forever."

Opposite: In Spring 2007, Vera's vintage prints, from geometrics to butterflies, were reinterpreted into contemporary fashion designs that remain faithful to the spirit of the original line.

Top: A duvet set from Anthropologie's Spring 2009 We (Love) Vera collection reinterprets the sinuous forms of Vera's classic Guru paisley.

Right: A watermelon print skirt made in partnership with Anthropologie for its We (Love) Vera Spring 2009 line.

2

An Original Vera

*"As a child drawing wildflowers,
ferns, and butterflies along
the banks of the Rippowam River
in Stamford, Connecticut, I dreamed
that someday I would be an artist."*

—Vera

Every Vera design, whether a dress or a poster or a dinner plate, was based on an original painting by the artist, who at her busiest averaged more than 500 per year. She was not only wildly prolific but also well-versed in a variety of media. Vera made studies in seemingly every material under the sun: pencil, pen and ink, thread, colored tape, batik, permanent marker, stamping, tissue-paper assemblage, acrylic, found-object collage, crayon, and many more. Sometimes she would paint directly on her blotter, a paper towel. Most often, though, she painted in bold, saturated watercolor, holding the brush in one hand and a phone in the other, under the watchful and loving eye of her menagerie of cats and dogs.

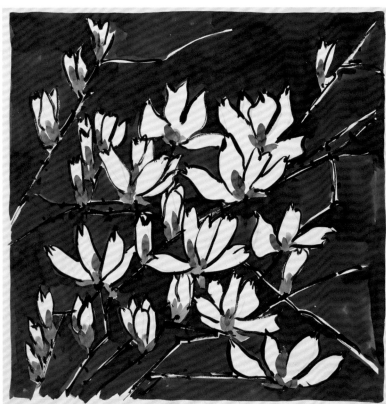
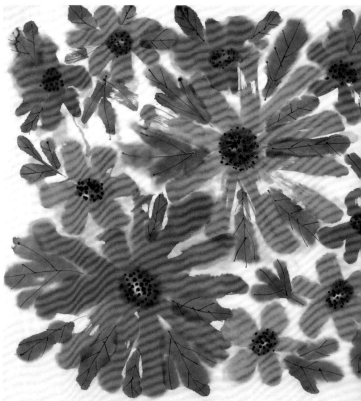

As Vera's popularity grew, so did her vulnerability to imitators. She and her legal team were proactive in sniffing out and confronting copycats. Vera successfully sued a large retailer for knocking off one of her designs—a polka dot! So in the 1950s, she began trademarking her name and registering the original artworks with the Library of Congress. She was one of the first big-name labels to copyright her designs—a prescient move, given that her artworks are still illegally copied today.

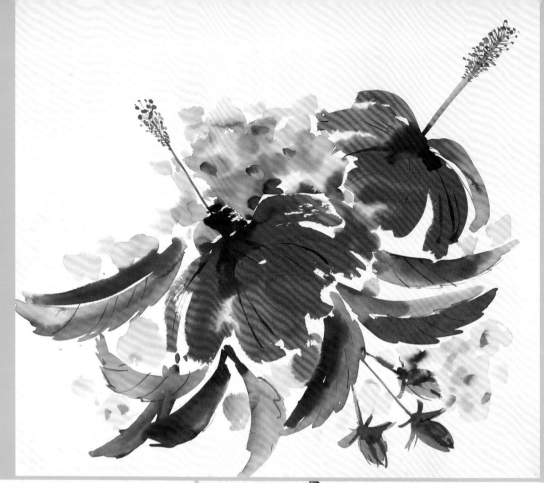

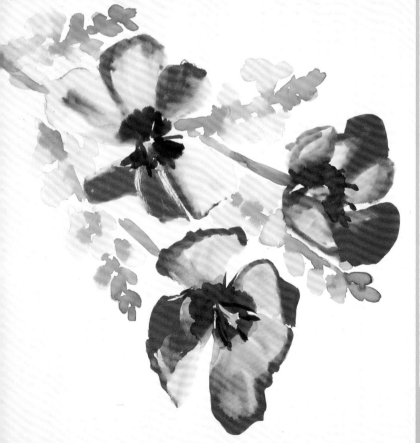

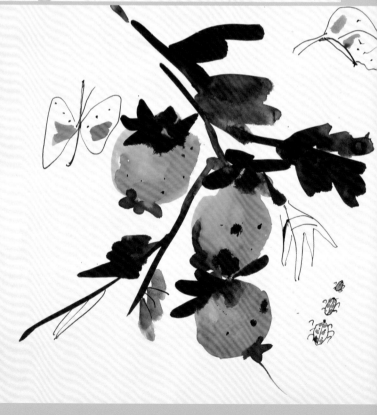

Sumi-e brushwork

Despite Vera's dexterity in such a wide range of media, she most often employed sumi-e, a Japanese phrase translated as "black ink painting." This ancient East Asian technique, in which the artist holds the brush vertically, was first practiced in China. Obsidian ink on white silk or paper created a strikingly graphic result. Sumi-e's swift, declarative brushwork exhibits an economy of line, a sort of dashed-off, from-the-gut gesture akin to Abstract Expressionist painting.

Vera, who had studied calligraphy when she was younger, perfected the sumi-e technique while in Asia. "The first time I was in Japan, I had a wonderful teacher. I really took to it," she said.[68] The style was well suited to her artistic sensibility; even her earliest drawings reveal a decisiveness characteristic of sumi-e. She explained the technique's appeal: "It allows me to leave out everything extraneous. With one brush stroke, I can be both impressionistic and graphic—you could *potchka* a canvas up with a lot of brush strokes, but it would add nothing and detract much."[69] Less was truly more.

Sumi-e enabled Vera's remarkable expressionism. The flowing lines artfully captured the evanescent beauty of plants and flowers. Although some of her paintings could be quite minutely detailed, even her densest compositions had an inherent spontaneity. Her brushwork was explained in her company's promotional materials: "It does not attempt to achieve detail but strives rather for the essence of a leaf, a flower, a form. It is roughly, rather than meticulously painted, abstract in concept and line."[70]

Above: Japanese-style sumi-e calligraphy entailed holding the brush vertically. Vera used the technique to achieve bold yet washy lines, which beautifully captured natural imagery (opposite).

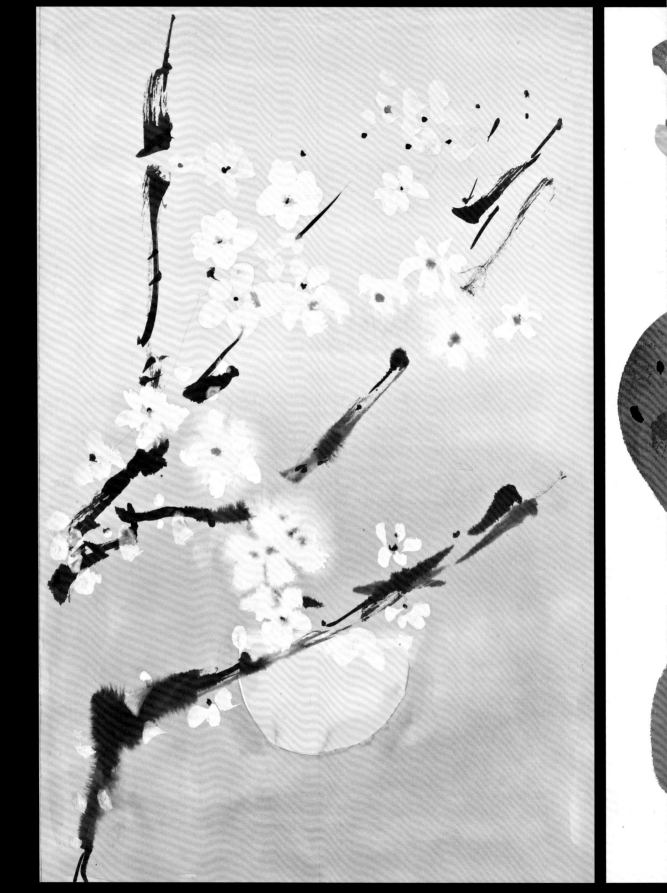

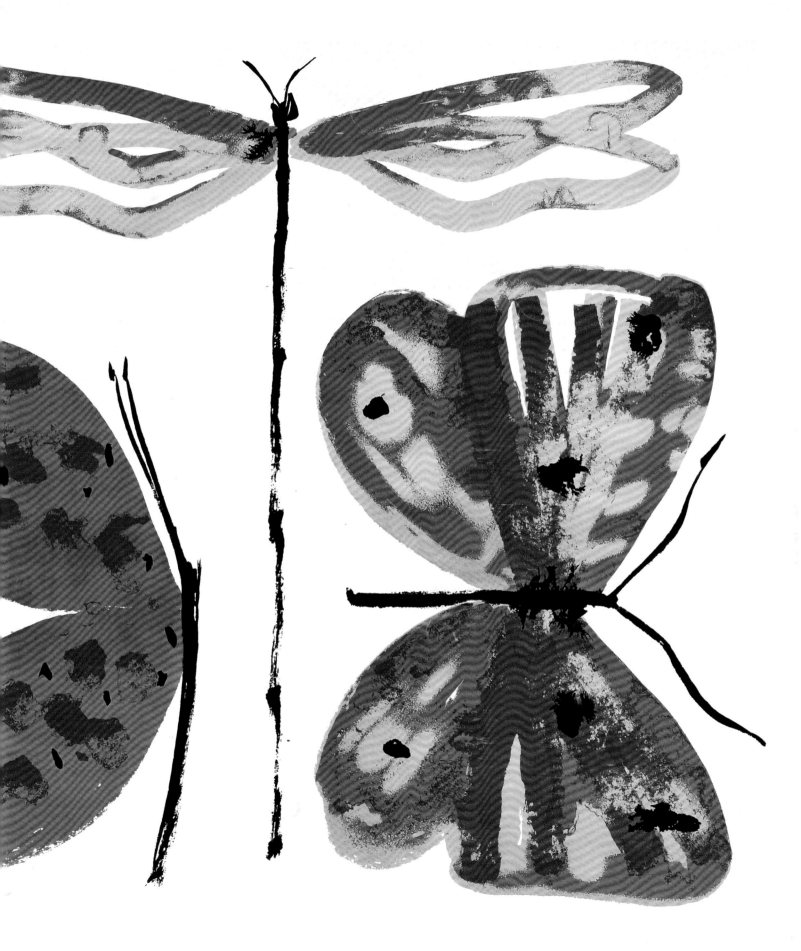

"Color is the language I speak best"

Although Vera became known for intense hues and unusual chromatic combinations—pink and gray, mauve and yellow—her designs were in fact remarkably spare compared with those of her contemporaries. "We were the first to break away from the idea that a scarf had to be designed with twenty-four colors. Why so many?" she noted in *Textile Industries* magazine in 1966. Vera chose the route of fewer colors, fewer gestures, to convey more of a spirit. "Color is such a marvelous way of expressing emotion," she said. "We have so many problems in this world, color brings just a little bit of joy into our lives."[71]

Vera brought color into her own life, too. Kimiko Matsuda, who spent summers working in the Manhattan showroom, would occasionally get a call from her grandmother on days when she came to New York City for business: "She would send me to Lord & Taylor to get a specific color of a certain Reebok high-top," she recalls. "For instance, if she wanted the Calder orange to go with a suit she was wearing."

Ever since she was a little girl, Vera loved to sketch. "My mother pasted big pieces of paper onto the cardboard dividers in shredded wheat packages, and I lay on the dining room floor painting pictures on them," she reminisced.[72] Vera drew inspiration from all around: her gardens, the produce stand of her local marketplace, her folk art collection, her kitchen table, clouds, birds, and even her desktop. Travel was a major source of imagery, motifs, and patterns, from the rich glazes and intricate shapes of Middle Eastern tilework to Turkish minarets to the archetypal forms of colorful Greek houses dotting seaside cliffs. She gave everything her own twist. "Using costumes, carvings, jewelry, and artifacts collected from her trips, Vera draws and paints her own versions of her subjects," her company biography explained.[73] She strove for a kind of authenticity that had more to do with interpretation than reportage.

A 1972 corporate documentary, *Vera Paints Ibiza in the Sun,* directed and produced by her nephew Fred Salaff, sheds light on her creative process. The camera follows Vera around the sun-drenched alleyways and courtyards of Ibiza, where she kept a pied-à-terre for many years, with her sketchbook in hand. Decked out in a mod turquoise blouse and a squash-blossom necklace, Vera would stop here and there, sitting on a low stone wall or at an outdoor café to capture traditional dances, pottery making, and Moorish architectural elements in watercolor and pen.

While Vera most often drew directly from life, she would very occasionally resort to a photographic source. One such instance occurred in 1966, when she was the inaugural recipient of the Joske's department store's Camellia Award for fashion excellence. As part of the honor, she was asked to create a likeness of the pink camellia bloom for the invitations.

"I received the request when there were absolutely none to be found anywhere. I finally worked out the designs from photographs," she confessed.[74]

Sometimes images just emerged from her subconscious. "I always sleep with a small sketch pad on my night table," she said. "I sometimes think of the most fantastic patterns at night and in the early morning hours. If a bird or squirrel passes, my two dogs bark and sometimes I wake up dreaming of a design."[75] Vera lived, breathed, and even dreamt about art.

Motifs

Many who worked in the studio contend that Vera preferred designing bold geometric patterns. But painting blooms, blossoms, and all things botanical was second nature. She felt immense affection for florals, and fans responded to her pure love of the subject.

Her imagery was incredibly diverse and often quite quotidian. Everyday objects such as eyeglasses, wine goblets, school buses, and ice-cream sundaes became wondrous objects in Vera's hand. Her portfolio also featured a number of recurring motifs. Here are some of them.

Above: A young Vera fan dons an age appropriate vintage scarf, a 1950s design ornamented with school buses.

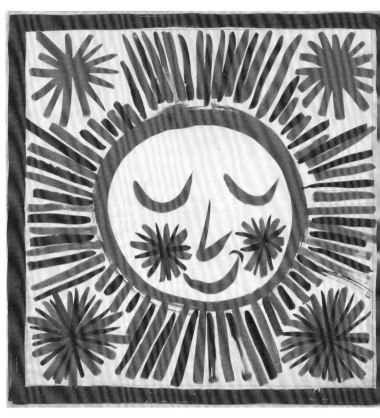

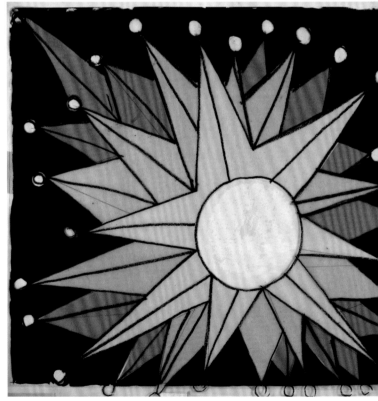

HAPPY SUNS

Radiant suns, Leo Vera's astrological sign (and a symbol of her upbeat demeanor), were included in almost every collection. Vera basked in the sun's warmth, no matter where she traveled, observing how its color and shape differed from country to country: moody and elusive in Scandinavia, naive yet intense in Ibiza. She often rendered the glowing orb in very abstract lines.

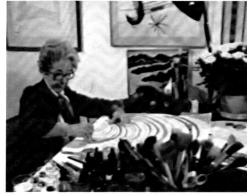

FISH

Big or small, striped or scaled, Vera's playful fish came in many guises. But they always had a smile.

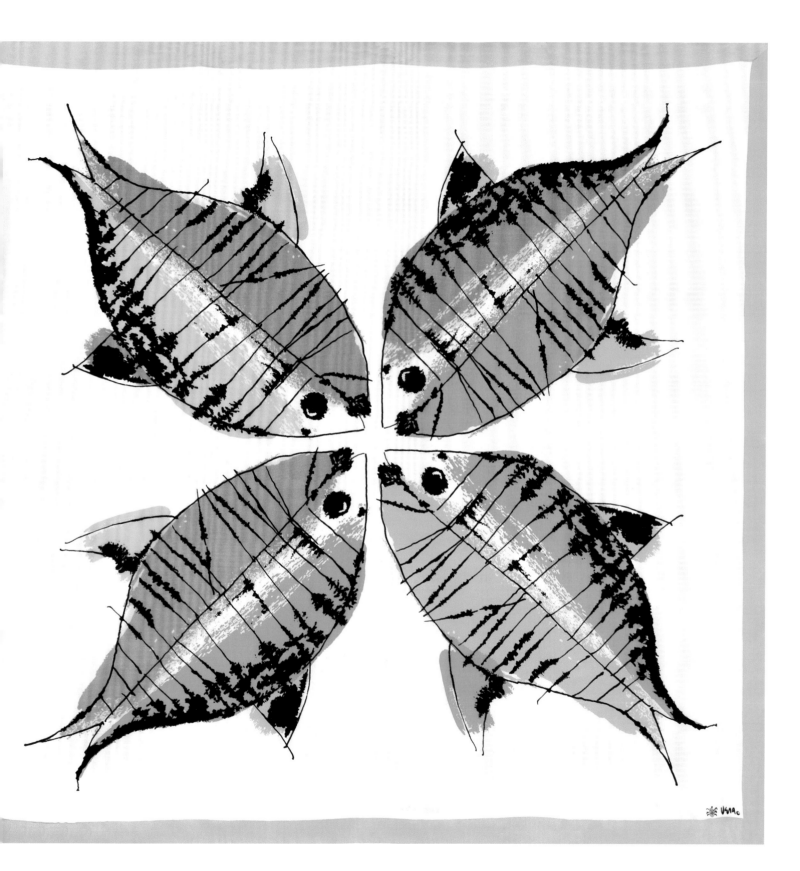

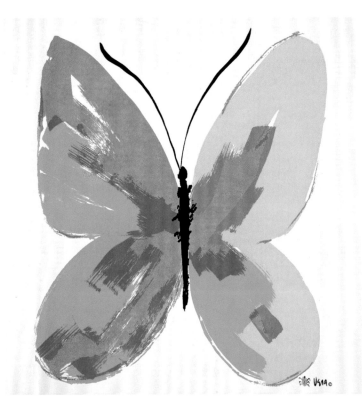

BUTTERFLIES

One of her more recognizable motifs, butterflies were an object of Vera's study ever since she was a child. Her depictions would range from more life-like to quite stylized. Flights of Fancy, one of her most popular patterns, bedecked everything from placemats to garments.

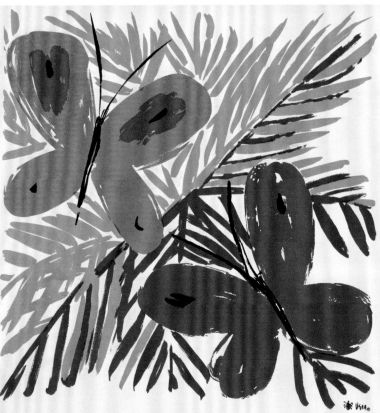

BOTANICALS

As fond as Vera was of blooms and blossoms, other natural forms, from dainty wheat fields to autumn leaves and luminous birch trees, were equally fascinating to her.

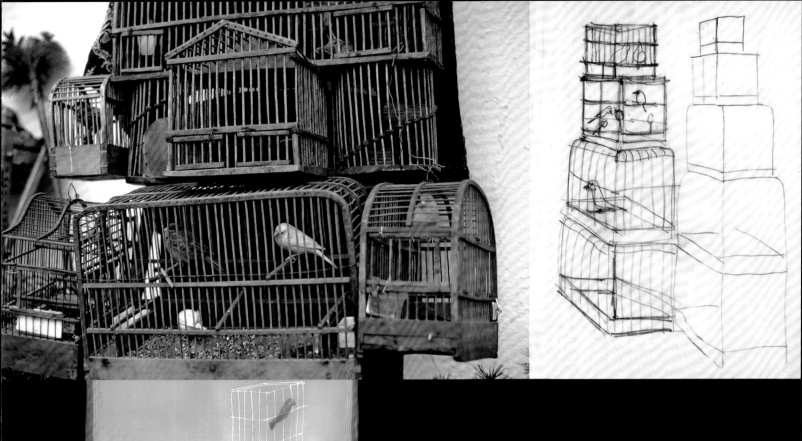

BIRDCAGES

A stack of birdcages that Vera spied on one of her many journeys led to a series of images that captured the source material's combination of dynamic geometries and avian forms. Vera herself was no caged bird; she was free to roam the globe as she pleased in search of inspiration.

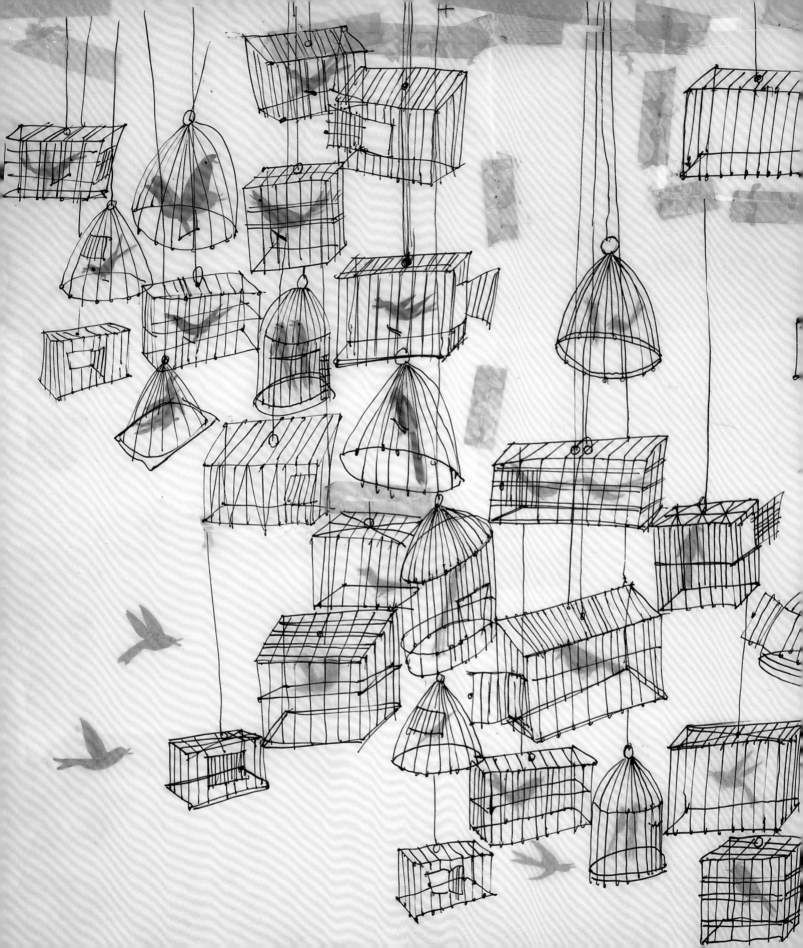

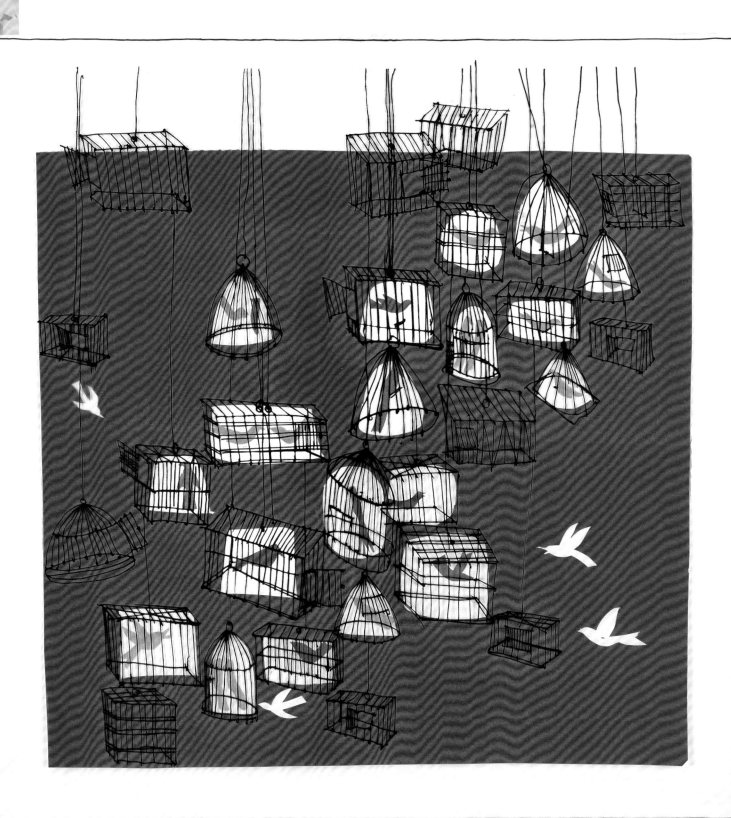

ABSTRACTS AND GEOMETRICS

Vera's abstractions are stunning in their variety. Some were stark monochromes, distilling color to its barest essence; others paired unusual color combinations like pink and red or explored the subtleties of a range of similar hues. Often the shapely forms were inspired by her surroundings—a view from an airplane, the overlapping curves of deer antlers—but they could also spring from a purer investigation of line, color, and form. She was known for bringing out op-art prints in the 50s, well before they came into vogue.

FLOWERS

More than any other subject, Vera's florals reveal the amazing breadth of her technique, which ranged from quite realistic to wildly expressionistic, veering on abstraction. Although daisies and sunflowers were among her favorite flowers as a young girl, Vera grew up to love geraniums especially and kept pots of them on the terrace of her Breuer house.

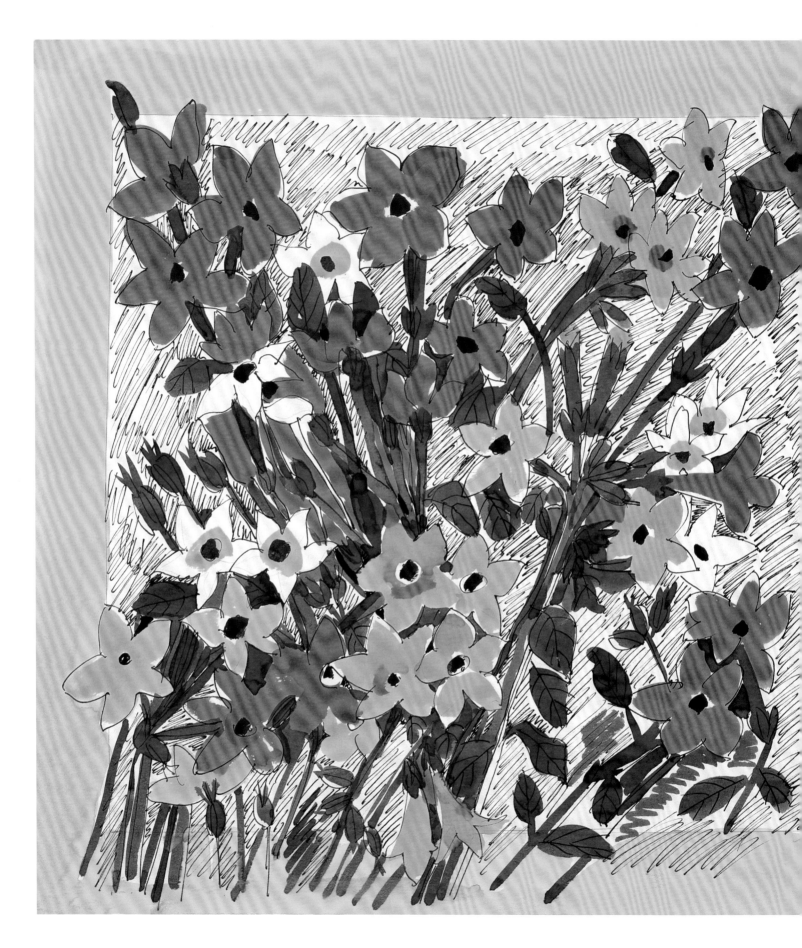

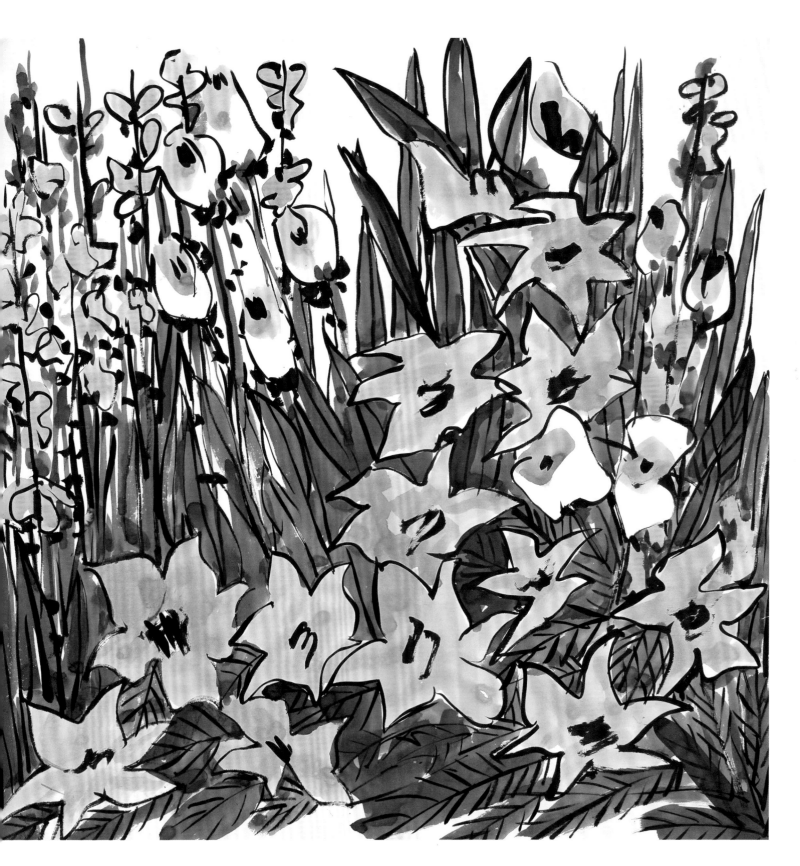

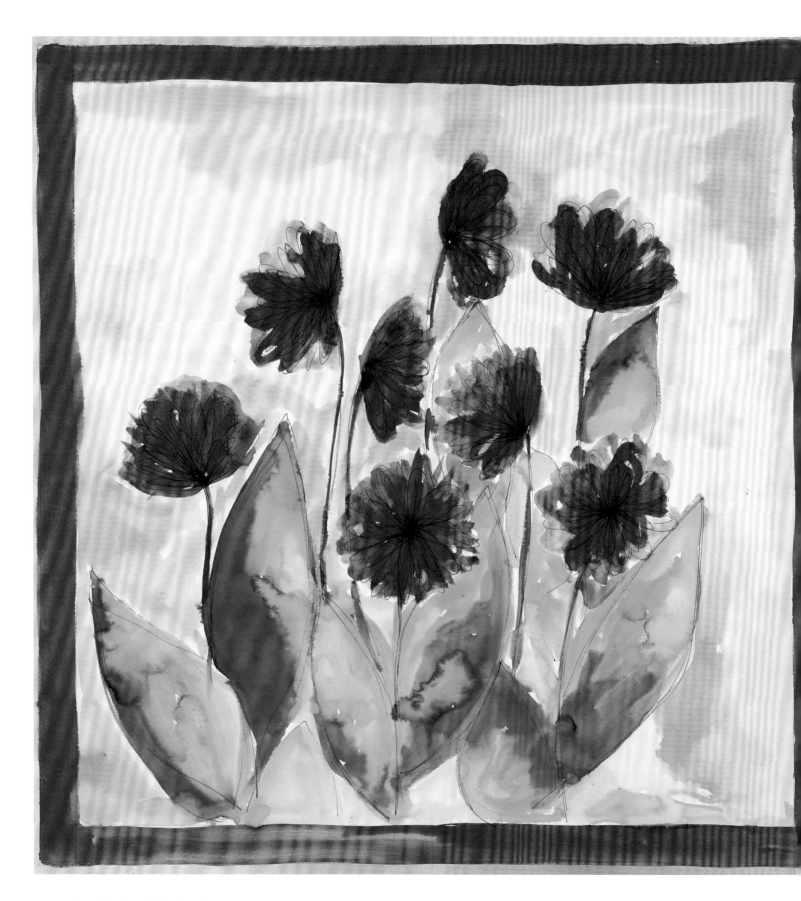

Art into design: from concept to creation

At the beginning of her career, Vera designed every single textile pattern that embellished her products, not only executing the original artwork, but painting its likeness directly onto the silk screen for printing. As the printing technology evolved into a photographic process, she still oversaw the translation of canvas into a screen separation. For her, the most challenging part of the process was "squaring off patterns or putting them into repeat," she explained. "Let's not say it's difficult, just bothersome."[76] So when her fledgling business took off in the late forties, she turned the task over to her production staff.

At the height of her prominence, in the late 70s, the volume of artwork required to create seasonal collections for her three divisions—housewares, scarves, and sportswear—was too much for one person to handle alone. A staff of twenty-five artists helped realize her designs, creating layouts and repeats and overseeing color separations for printing. Even with a full staff of painters at her disposal, collections would still spring from Vera's own hand. "We work different ways. I take a trip, bring back sketches, and sometimes I develop them, sometimes I give them to someone else to develop. But it all starts from my drawing board, and is mostly inspired by travel."[77] She would conceive each season six to twelve months prior to market week. After executing original paintings based on the chosen theme, she'd edit them into a cohesive grouping. She grew adept at making her works on paper in a manner that would easily translate to the format of the final product, whether a long, skinny silk scarf or a huge duvet cover. "I think in the shape of a canvas," she said. "I always paint or sketch and then I see how the design might work into other things."[78]

Her paintings would be hung on huge rolling racks in the studio, to be presented to the creative teams of each division. "She would literally paint 100 artworks," Gretchen Dale recalls. "We would all gather together, and she would sell her ideas to us; she was always very convincing." Adds Joan Reil, "She was really good at selling. She'd get her coffee and her croissant; a little bit of a fuss was made on her part so she could relax. She wanted to please— and she was captivating."

The design directors would pick what they were most excited about and start building the collection from there. Sometimes division heads would all gravitate to the same patterns, which is how they ended up on both a scarf and a tablecloth; coordination was not deliberate, but it proved an effective way to cross-promote. There would be lots of back and forth with Vera over the following months, as studio artists mocked up layouts and ideas for her to approve. "It was a collaborative, organic process. We were in constant motion for six months, working on numerous collections in various stages all at once," says Dale.

Although she had a strong creative vision and personally signed off on every design that left her studio, Vera was also known to give her deputies a wide berth. "Even something as simple as a daisy can give the artist a little chance to inject his own feeling," she said. "But it has to be seen by me, because the flower has to be seen within a certain square and it must properly fill the repeat."[79] Surrounding herself with such amazing talent enabled her to spend the majority of her time doing what she loved best, *creating*. It's one reason she appreciated her staff so much.

Prints charming: the screen-printing process

When Vera first started producing textiles based on her paintings, she silk-screened the fabric by hand on her dining room table. But once business took off, she and George scaled up the operation and embraced industrialized methods.

Vera was determined to prove that commercial designs could offer the same level of quality and craftsmanship as original artworks. The key was creating mass-produced designs that reflected the artisanal touch and joyous spirit of her paintings. From its inception, Printex pushed the limitations of technology to capture subtleties of brushwork and coloration. At the same time, Vera was careful to conceive her renderings with their eventual reproduction in mind. From George, she learned what effects best translated into the print medium: saturated colors, forceful lines, and pared-down but dynamic compositions. She worked closely with the artists in her studio to share these insights.

Printex primarily produced yard goods and small items like vinyl place mats; more complex designs like panel-printed tablecloths were made off-site. Today, textiles are often designed digitally and printed by computerized machinery. In the mid–20th century, however, the production process was still very hands-on. At first,

"We used to go out into the woods and select leaves and then simply photograph them flat onto the screen," said Vera in 1975. But things got more sophisticated in the late 50s and 60s. "In the early days, I used to paint directly on the screens in silk-screen printing," Vera said. "I had to have a union card so I could wash the dirty screens. Now it's done photographically."[80]

The laborious color-separation phase began after Vera's original paintings had been translated into a final composition with the exact dimensions and layout of the final product. This artwork was placed atop an enormous light table and a transparent acetate sheet was laid on top. Working on one color at a time, studio assistants blocked out each hue with black ink; a separate acetate sheet was used for each color. (Vera's designs often included up to seven hues.)

In the darkroom the color separations were photographed onto film to make a permanent copy. This negative would be transferred directly onto silk stretched taut over a wood frame, i.e. the silk screen. The silk was coated with a light-sensitive photo emulsion and the film negative applied by vacuum pressure. The emulsion hardened everywhere but the blocked-out shape, just like a stencil, leaving behind porous silk that admitted ink during printing.

While the workmen built a silk-screen frame for each color in the design, dye chemists would formulate the inks, which were mixed in paint buckets. The composition and hues were then tested in a series of strike-offs. (Vera's brother, Philip, was an integral part of the production side, overseeing much of the sample printing.) With the designer's approval, printing then began. Long bolts of fabric—cotton, linen, silk, or various synthetics, depending on the final product—were unfurled along a 120-foot-long table. Printers applied the colors one after another; a screener would start at one end of the bolt and work his way to the far end. This step involved rolling ink onto the screen and squeegeeing it across the fabric,

then sliding the screen a few feet down to make the next repeat. After that ink dried, a second color was applied right on top. The technician repeated this phase until the entire composition was completed. Pigments were fixed by steam heating, and the fabric was then washed, dried, stretched to the proper width, and cut as needed.

As automated screen-printing technologies were developed in the 60s, Printex jumped on board. The company purchased top-of-the-line Reggiani and Buser machines from Europe, each of which could do the work of twelve artisans and print on myriad fabrics.[81] The machines replaced the hand-application of ink to fabric by using printed rollers. The process, however mechanized it became, nonetheless relied on many layers of human intervention, from colorists mixing inks to Vera's specifications, to technicians whose painstaking exactitude helped mimic in printed form the liveliness of the original drawings. Technicians even maintained a library of hues used throughout the years so their exact chemical formulations could be recreated as desired.

Technology and artistry went hand in hand at Printex, but so did art and business. The company was fully vertically integrated, from design to distribution, which offered a number of advantages. Studio artists were privy to the minutiae of the printing process and quickly learned what compositions would best translate from paper to fabric. They could also review samples and strike-offs frequently and quickly, thus reducing the lag time between initial concept and sales floor. The process allowed Vera a high degree of experimentation since it could produce limited runs; Printex was a sizable operation but not a high-volume one. "With our vertical setup, no one is breathing down my neck or reminding me that every new design must sell in large quantities," said Vera. "The attitude here is that if I have so much confidence in a new idea, that if I have such a strong feeling about it, we ought to go ahead and put it into the line even if it doesn't sell in volume."[82]

Joan Reil remembers these sentiments put into action. "We would sometimes print fabrics for a photo shoot, even before there were purchase orders! Vera loved taking chances." Says Vera, "We all realized that to be a leader we had to stick our necks out."

Opposite: An enormous light box for making color separations by hand glowed brightly in one darkened room.

Below: Studio assistants traced Vera's artwork onto transparent acetate, the first step of the color-separation process.

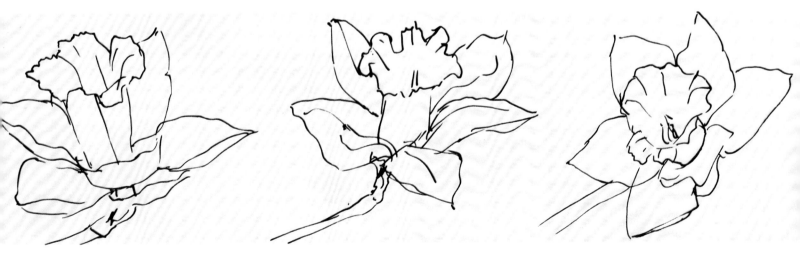

BRIARCLIFF COLLEGE MUSEUM OF ART
TONAY SCHUBERT — Curator
Vera Poster Retrospective
November 6th - 28th • Open to the public daily

Vera paints a Persian garden

paintings, printings, limited editions for spring THE VERA GALLERIES January 6th–31st, 1969

NEW YORK BOSTON SAN FRANCISCO DALLAS LOS ANGELES
117 Fifth Avenue 99 Classon Street 324 Market Street Dallas Apparel Mart 110 East Ninth Street

THE ART OF THE POSTER

Vera publicized each season's collection, not only through typical sales vehicles like advertisements in Vogue and Glamour, but also through the production and distribution of silk-screened posters featuring an iconic image from the line. Her Persian Garden collection from 1969, for instance, was announced with an abstracted white tree silhouetted against bright pastel blocks of color that conveyed the

Top left: The poster announcing Vera's 1973 poster retrospective, held at the Briarcliff College Museum of Art, was based on this geometric-print scarf (opposite).

Top right: The signature image from Vera's Persian Garden collection is an abstract rendering of a cypress tree.

Below: Bold hues encountered in Africa inspired the graphics for this promotional poster.

Opposite, left: Vera voyaged to Japan a number of times, both for creative inspiration and to visit factories producing her Mikasa china. There she painted everything from views of Mount Fuji to delicately decorated handheld fans.

The Vera Galleries

New York: 417 Fifth Avenue San Francisco: 821 Market Street
1411 Broadway Dallas: Dallas Apparel Mart
Boston: 99 Chauncy Street Los Angeles: 110 East Ninth Street

Vera
san
paints
Ja
pan

Vera
paints
symbols
of
the East

The Vera Gallery Showrooms: New York, Boston, San Francisco, Dallas, Los Angeles, Chicago, Denver, Charlotte, Seattle, Minneapolis.

sultry hues and arabesque geometries of the Middle
East. (The collection was launched at the newly expand-
ed Printex plant in Ossining.) Vera-san Paints Japan
channeled the Orient through gestural calligraphic
forms. A rainbow-striped sun emblazoned across a
metallic gold background captured the vibrancy of Jewels
of India, a collection of harem pants and sari-influenced
garb. These were distributed at press and sales events
to build excitement about the coming season's novelties.

She was often commissioned to devise posters promoting other organizations besides her own. A consequence of her globe-trotting, Vera was a de facto ambassador for travel bureaus and airlines of countries like Brazil. Boats in turquoise and yellow glide across an artwork promoting TAP Portuguese Airways. The country's wine industry, meanwhile, was pitched with a cluster of pink and purple grapes: "Vera paints a taste of Portugal."

To Vera, posters equaled approachable and affordable artworks, and her simple, arresting graphics were well suited to the medium, but commercialism was only one facet of her work in the form. A supporter of numerous charities, Vera made posters to raise awareness for some of the causes she supported: the Americans for Indian Opportunity, for which she

Right: A bunch of pastel grapes was the chosen iconography to promote Portugal.

Vera paints a ta

Portugal

of Portugal

 Portuguese Airways

created a poster promoting a Southampton summer bash in 1970; the St. Christopher's School Annual Fall Fair in Dobbs Ferry; New York Mayor John Lindsay's Playlots and Scholarship Fund; and many others. Such educational organizations were also the lucky recipients of proceeds from the sale of posters announcing her art retrospectives, including her 1972 Smithsonian program and 1970 Emile Walter Gallery show, the latter of which benefited the Fashion Institute of Technology.

Americans for Indian Opportunity
Southampton, July 11, 1970

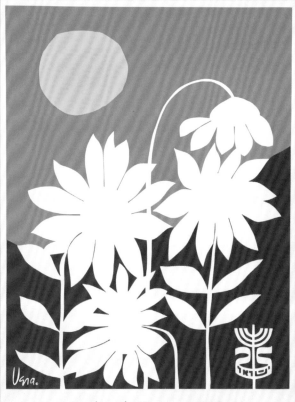

Hadassah/Denver/1973

In 1973, the Briarcliff College Museum of Art mounted a Vera poster retrospective, which included twenty-three designs created between 1966 (Vera Paints Peru) and 1973 (Vera Paints Symbols of the East). The brochure contextualized Vera's efforts within a long tradition of artists who embraced the medium. Vera was in good company: Picasso, Miró, and Chagall, artists she collected and admired, all designed posters promoting their exhibitions, too.

hristopher's School Dobbs Ferry, N.Y.
ual Fall Fair, Saturday, October 21, 1972 10am 5pm

Vera paints Carnaval do Brasil

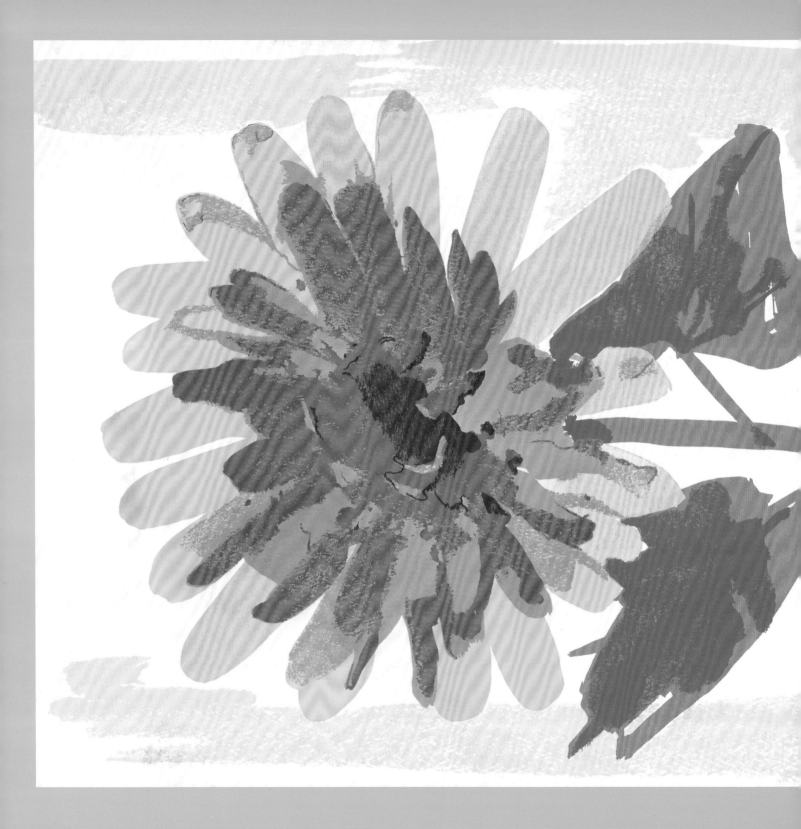

Oh, the fun of looking
at the Summer Sun,
a joy for us to see and
bounty for bird and bee!

Alice Siegel

Vera

to plant seeds and watch
the renewal of life is one
of the greatest delights of man

8/100 Vera

3

Fashioning a Brand

"To me, fashion is an ever-changing art."

—Vera

In 1960, Vera fashioned two scarves into her first garment, the Jollytop, a flowing, square blouse. Within six years, she had developed a comprehensive line of sportswear that was sold in 4,000 stores. The collection ballooned into myriad product categories: pullover tops, shirts, shifts, tunics, and dresses. Plus solid-color pants to coordinate with all her brightly hued tops.

But it all started with the scarf.

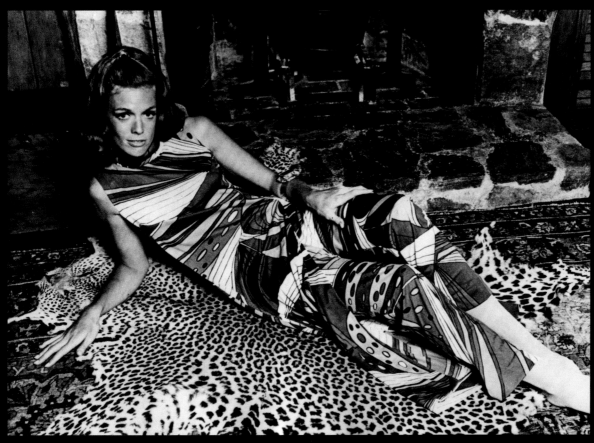

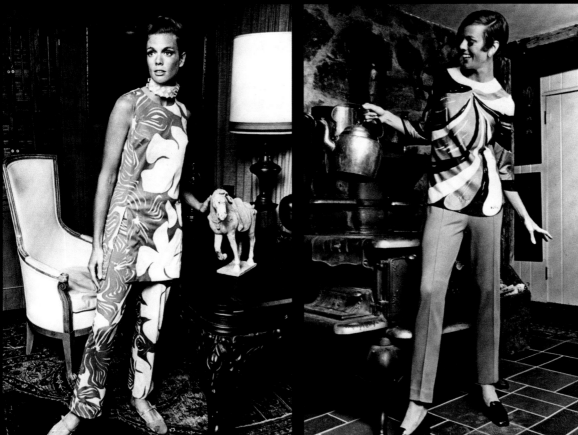

Vera's 1967 O'Rainbow collection featured mod shifts, tunics, and a floor-length "glide" with matching pants, all bedecked with abstractions of cobblestones, shamrocks, and the Emerald Isle landscape.

The scarves: from Verabouts to winglets

Vera started designing her iconic scarves on army surplus silk in 1945, after wartime cut off the fabric supply for small businesses. She expanded from there, creating designs on numerous fabrics, from hammered silk to nylon Vera Sheer. As volume increased, some production was moved abroad to Italy, Japan, and even China. Indeed, Vera distinguished herself as the first American designer to manufacture product in the People's Republic destined for U.S. sale.

She offered scarves in assorted shapes and sizes. The most popular were 36- or 44-inch squares, but rectangles, wedges, and long skinny bands of silk were also in vogue. A series of slim strip scarves and triangles called winglets could be worn like bracelets or tied together at the corners to create a sort of bib. Scarves from her Gold Coin collection featured a small gilded charm dangling from one corner. The company promoted scarves, not as an optional accompaniment, but as a fashion *necessity*, one that needed to be replenished every season. "Vera was in the business of making last

month's design obsolete," says Joan Reil, who worked with the company from 1981 to 1988, eventually becoming creative director of scarves and linens. "She had to constantly create newness and a reason to purchase."

Vera's style was au courant without being trendy. "She had a keen eye for clean looks," Reil says. "I remember telling her once that tight outlines around flowers were all the rage. She'd nod and come back with her beautiful paintings, the outline always *off* the flowers. She did what she wanted—I loved that about her. She was confident in her convictions and did not get wrapped up in trends."

Vera's aesthetic was so ahead of the curve that she often reworked motifs from her previous collections, stored off-site in a warehouse in Wilkes-Barre, Pennsylvania. "Jungle prints would be big and she would say, 'Oh yes, I did a great jungle print ten years ago,' and we'd pull it out of the archives," says Reil. "She had seen everything come and go." She was always timeless.

Square-format scarves were among Vera's most popular, although other shapes, such as triangles, had their moment in the spotlight.

The art of scarf tying

Joe Bruno worked for Vera Industries from 1962 to 1992, graduating from linen sales to promotions manager for scarves and linens. "I started when the company was very tiny and saw it grow quite big," he explains. Tiny though it was from an organizational standpoint, Vera Industries sold a huge volume. "Before joining the company, I was a linen accessories buyer at Bloomingdale's, where Vera's designs just *flew* off the shelves."

As one of the company's public faces, Bruno traveled across North America performing in-store product demonstrations. His ambassadorship started with an impromptu napkin-folding performance at Lord & Taylor in New York in the mid-1960s. A representative of the silver shop Georg Jensen happened to be in the audience. "He called the next day and said, 'I know we don't carry Vera, but could you please do a tabletop demo for brides in our store?' I was floored." Bruno found himself with a new job, and developed presentations for table setting, napkin folding, and scarf tying. He even self-published a scarf-tying manual for audience members to buy. Among Bruno's biggest accounts were Moss Brothers, Bloomingdale's, and B. Altman in New York, Higbee's in Ohio, González Padín in Puerto Rico—and Dayton Hudson in Minnesota: "They sold thousands in a day! A lot of challis and wintry looks." Tastes, he explained, proved quite regional. "In New York, the customer went for big, bold styles."

Bruno also orchestrated market-week presentations, when designs would be sold to buyers in the Manhattan showrooms. Inspired by Vera's nephew, photographer Fred Salaff, who documented the company's inner workings in a series of corporate films, Bruno created slide shows of products to dazzle buyers in the company's projection room at 417 Fifth Avenue. Lifestyle tableaux would be photographed in the showroom or sometimes in Vera's house. ("Once I accidentally used her Calder elephant as a prop on the edge of a cliff behind her house, not realizing that it was a sculpture!" he recalls, adding that a panicked stylist quickly returned the piece to its rightful place on Vera's back patio.) He produced multimedia presentations by running multiple projections simultaneously. "The first time I tried to put one together, it didn't work," he recalls. "I pushed a button and absolutely nothing happened." Luckily he could rely on his own salesmanship.

Although Bruno's presentations generated many sales, he takes little credit for his contributions. "It was all about Vera and her designers developing the right kind of product."

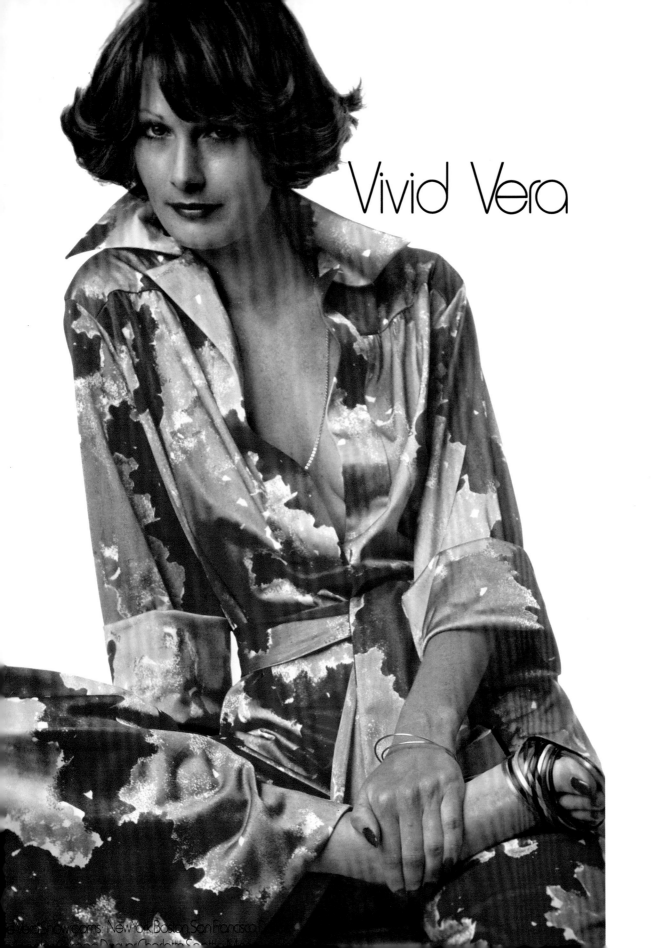

Vivid Vera

Sportswear: from Jollytops to flutteries

Her clothing line grew rapidly. To Vera, sportswear was a medium that could tolerate a bit of levity. "She poked a little fun at the whole fashion thing; she didn't take it too seriously," says Joan Reil. Hence her fanciful forms, from princess dresses to bell-bottomed jumpsuits, and her poetic names. Take her version of the minidress: "Less than a dress, more than a shift. It's a fluttery," the tag line explained. She also experimented with fabrics, embracing synthetic yarns like Ban-Lon nylon and Dacron challis.

In 1975, Vera hired a talented up-and-comer, Perry Ellis, to be her vice president of merchandising. She quickly offered the fashion prodigy the top design post. He brought a chic sophistication to the line, incorporating linens and new-weave constructions. His star rose quickly; a year later, Manhattan Industries gave Ellis his own label, Portfolio. He once called his former boss an "American Sonia Delaunay, especially in her color sense. She is very much an artist and has trusted the people around her to handle the business."[83]

Opposite: A magazine ad from the 1970s showcased Vera's hot-pink jumpsuit. The company advertised in publications such as *Vogue, Glamour,* and *The New Yorker.*

Top: Perry Ellis, who designed Vera Sportswear in the mid 1970s, reviews a fall look in Fred Salaff's corporate documentary, *In the Company of Vera.*

Bottom: A still of the sprawling Secaucus warehouse from Fred Salaff's *In the Company of Vera.* All Vera products were inventoried and inspected here before they were shipped to retailers.

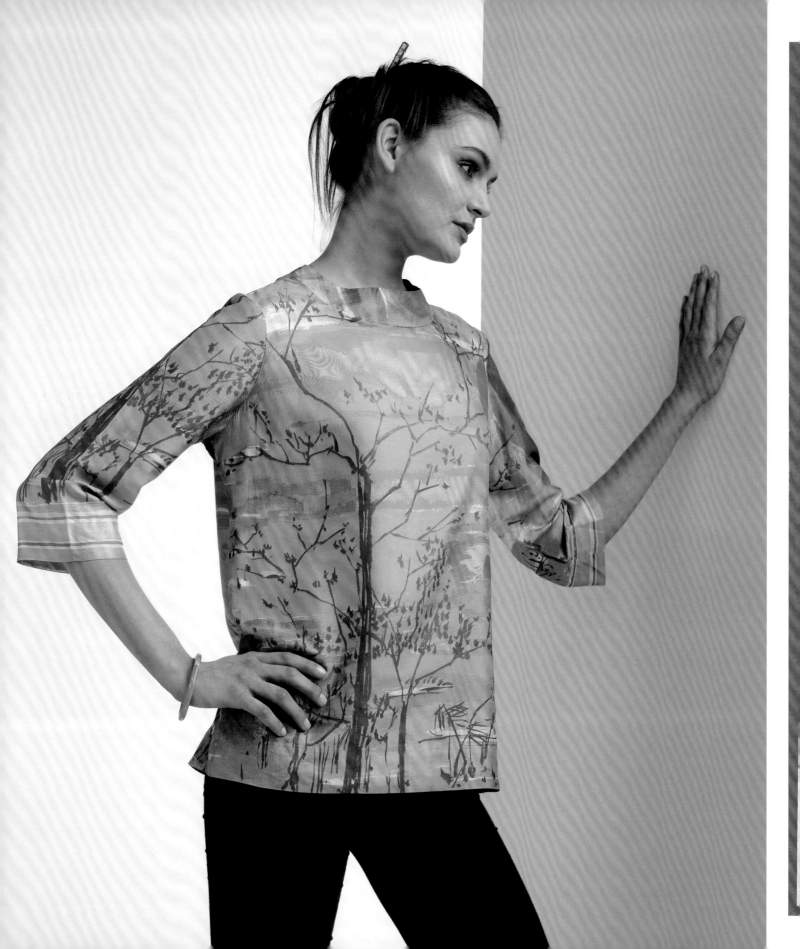

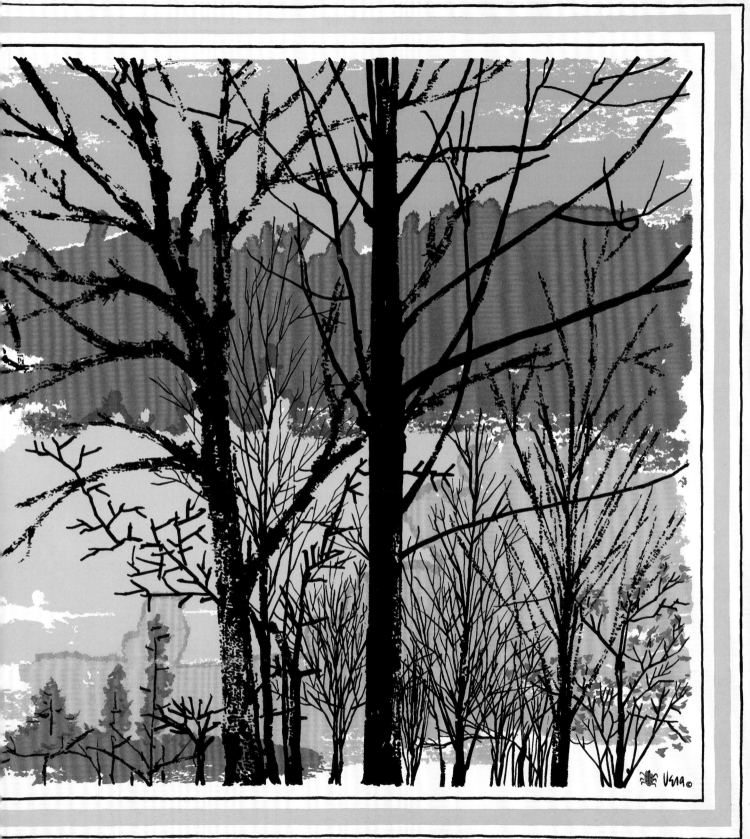

Wearable art: engineered-panel printing

Vera's blouses and dresses were distinctive for their vibrant prints and for the way those prints draped the body. The company pioneered engineered-panel printing. Instead of printing designs onto yardage and cutting the clothing patterns, the process worked backward. Prints were laid out for each pattern piece. Vera often painted directly on a mannequin to produce her swirling lines, radiant suns, and kinetic paisleys. A sales brochure described the process and its unique effect: "It starts, always, with a Vera painting. Before the design is printed, her art staff separates the artwork into various colors in preparation for screen printing. Next, a special paper mock-up of the dress is created to visualize exactly where the print will fall on every part of the dress. Cuffs, sleeves, collar, belt—each require their own design treatment." It looked as if one were wearing a painting. Fashion writer Mildred Whiteaker, writing in the *San Antonio Express-News* in 1966, marveled at "the precision with which the (pattern) on the front of the blouse meet(s) despite the necessary opening. It's 'seeing is believing,' as is all of Vera's artistry."[84]

Previous spread, left: A vintage silk blouse features a Chinoiserie-inspired motif of skeletal tree branches silhouetted against bold strokes of color.

Left: Vera was renowned for her panel printing: each piece of the garment—the front, back, arms, and neck bands—was decorated separately, so the pattern would fall into place when draped on the body.

Marketing: from the Vale of Kashmir to Danish-To-Go

Vera's greatest source of inspiration? Travel. Her collections were typically themed to a particular destination, such as Japan or Mexico or Peru. Launches were splashy affairs and often involved tourist bureaus and consulates. The Yugoslav Wine Institute sponsored the press preview for her fall 1972 Evening in Yugoslavia line. While models showed off ensembles accessorized with handcrafted jewelry that Vera had bought abroad, journalists were taught the country's traditional toast: *Ziveli*.[85] Danish-To-Go, released in fall 1968, was previewed at the Plaza's Baroque Room on models carrying parasols and sporting long braids to the accompaniment of polkas played by the Royal Danish Orchestra and the Tivoli Concert Hall Orchestra. For the occasion, the Danish consul general commissioned a 20-tier plum cake with almond pastry envisioned by the head chef of SAS Airlines and flown in from Copenhagen. (If guests had any appetite after partaking of the 60-foot Danish smorgasbord.) At the Jewels of India preview, a booklet was distributed to explain the country's customs and cooking techniques; it even included recipes.

Nancy Kristoff marveled at the company's sophisticated marketing machine. "We had a phenomenal promotions department. There was always a story, usually about wherever Vera had traveled to, that carried through from the market party to the posters. It was so well orchestrated. No one in the industry promoted that way."

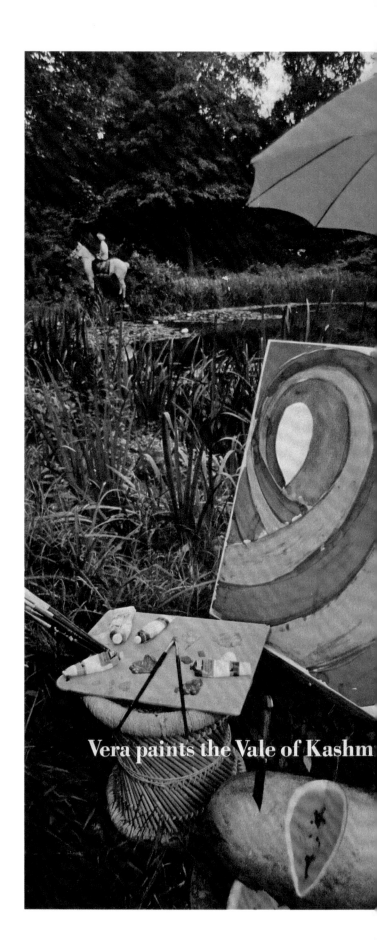

Vera paints the Vale of Kashm[ir]

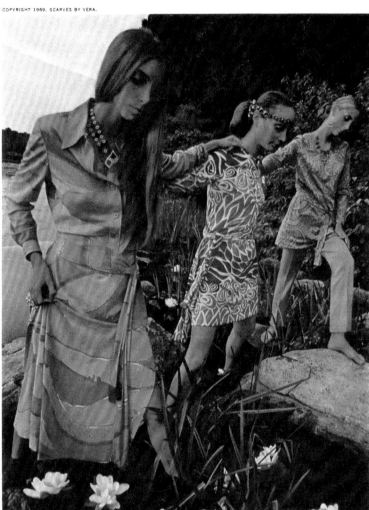

Vera wraps you in the verdant green of the Vale of Kashmir. Wear Vera's sun-splashed, water-dashed "Kashmir" canvas as a silk scarf for head, shoulders, waist, what-you-will, $8. Or, left: Wrap yourself full-length in it as a toe-touching, fringe-sashed sheath, $50. Center: Shift into fashion high with this shift that has its own sash scarf, $38. Right: Languish in a belted tunic, $30, with Ban-Lon® stretch pants, $16. Most in sizes 6 to 18. Prices slightly higher in the west. Vera's Vale of Kashmir is at fashionable stores now. In Ban-Lon® knits.

...for you to wear

Vera

FOR ART LOVERS

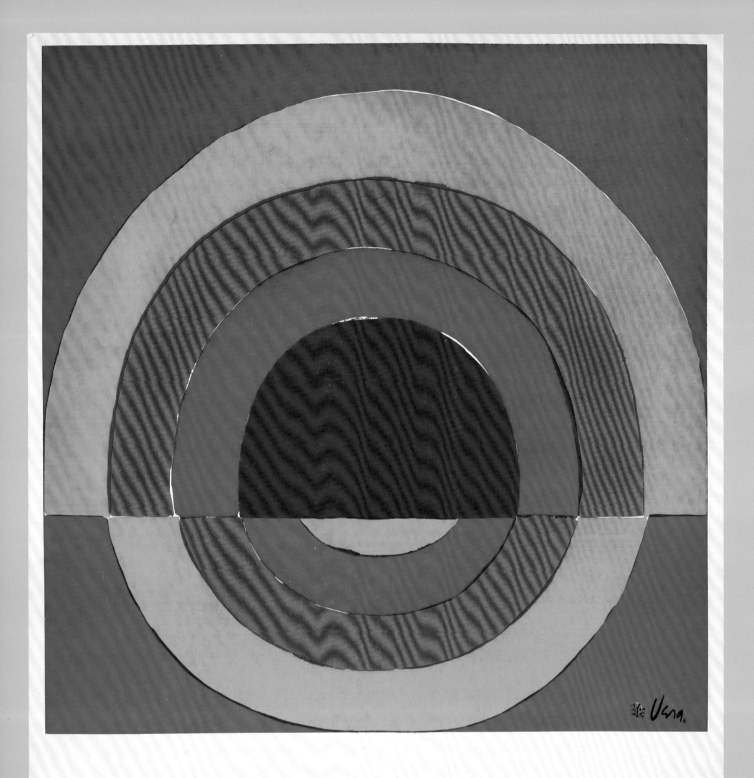

Vera paints an O'Rainbow

A trip to Ireland inspired Vera's fall 1967 O'Rainbow collection, featuring "heraldic and floral prints, in colors such as Galway blue and leprechaun orange—shades of the Emerald Isle." [86] *Scarves and tops bearing cobblestone and shamrock imagery were previewed in her showroom to a background of Irish jigs.*

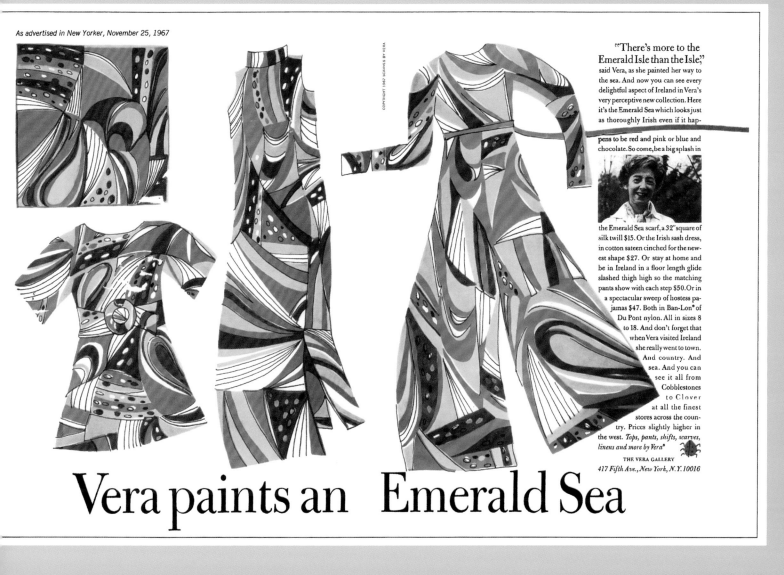

As advertised in New Yorker, November 25, 1967

COPYRIGHT 1967 SCARVES BY VERA

"There's more to the Emerald Isle than the Isle," said Vera, as she painted her way to the sea. And now you can see every delightful aspect of Ireland in Vera's very perceptive new collection. Here it's the Emerald Sea which looks just as thoroughly Irish even if it happens to be red and pink or blue and chocolate. So come, be a big splash in the Emerald Sea scarf, a 32" square of silk twill $15. Or the Irish sash dress, in cotton sateen cinched for the newest shape $27. Or stay at home and be in Ireland in a floor length glide slashed thigh high so the matching pants show with each step $50. Or in a spectacular sweep of hostess pajamas $47. Both in Ban-Lon® of Du Pont nylon. All in sizes 8 to 18. And don't forget that when Vera visited Ireland she really went to town. And country. And sea. And you can see it all from Cobblestones to Clover at all the finest stores across the country. Prices slightly higher in the west. *Tops, pants, shifts, scarves, linens and more by Vera®*

THE VERA GALLERY
417 Fifth Ave., New York, N.Y. 10016

Vera paints an Emerald Sea

Hi Vera. Bye Vera.

Yes, you've got to be fast if you want to talk to Vera: the painter, designer and constant searcher-outer of new things to paint for her Ban-Lon® collection. Here you see just one from her gallery of waves and rays and flowers and leaves and so on. All on Ban-Lon® shifts and shafts and flares and smocks of DuPont nylon that stays fresh and unwrinkled even if you're on the go as much as Vera is. See them all including New Leaf in sizes 8 to 18, $26 to $36 at Jordan Marsh, Boston and Miami; B. Altman, N.Y. (all branches); Julius Garfinckel, Washington, D.C.; Bullock's, Calif. (all stores); Milwaukee Boston Store, Milwaukee; Bon Marche, Seattle. Prices slightly higher in the West. *Tops, pants, shifts, scarves, linens and more by Vera®* THE VERA GALLERY *417 Fifth Avenue, New York 10016*

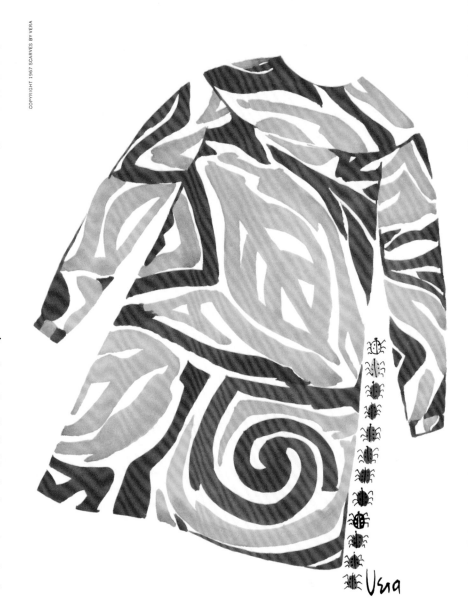

Vera paints a New Leaf against a Ban-Lon® sky of DuPont nylon

Glamour—May, 1967

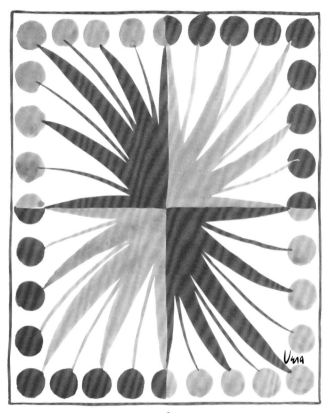

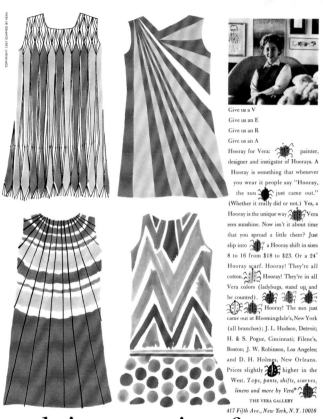

Give us a V

Give us an E

Give us an R

Give us an A

Hooray for Vera: painter, designer and instigator of Hoorays. A Hooray is something that whenever you wear it people say "Hooray, the sun just came out." (Whether it really did or not.) Yes, a Hooray is the unique way Vera sees sunshine. Now isn't it about time that you spread a little cheer? Just slip into a Hooray shift in sizes 8 to 16 from $18 to $23. Or a 24″ Hooray scarf. Hooray! They're all cotton. Hooray! They're in all Vera colors (ladybugs, stand up, and be counted). Hooray! The sun just came out at Bloomingdale's, New York (all branches); J. L. Hudson, Detroit; H. & S. Pogue, Cincinnati; Filene's, Boston; J. W. Robinson, Los Angeles; and D. H. Holmes, New Orleans. Prices slightly higher in the West. *Tops, pants, shifts, scarves, linens and more by Vera®*

THE VERA GALLERY

417 Fifth Ave., New York, N.Y. 10016

Vera paints Hoorays and signs one just for you

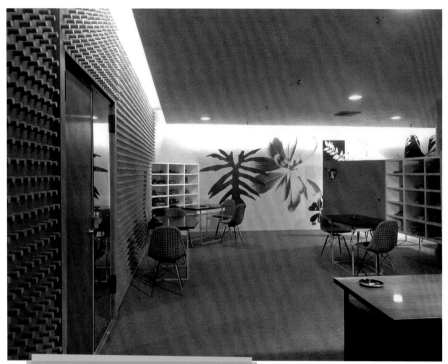

The Breuer showrooms

Vera's architect of choice, Marcel Breuer, who designed her Croton-on-Hudson home, also envisioned her showrooms in New York and Los Angeles. The first, for scarves and linens, was completed in 1952. Located at 417 Fifth Avenue, it was the epitome of visual restraint. Products were hidden in wall partitions and pulled out just for presentations, which both heightened the anticipation and kept the open-plan space uncluttered, with judiciously placed vignettes of Eames wire chairs and hexagonal tables. One entire wall was dotted in cork stoppers for texture. Otherwise, the only ornamentation was a run of narrow shelves on which Vera displayed folk art, including Peruvian pottery and a Mexican candelabra.

Breuer later masterminded her sportswear showroom in the Manhattan Industries building at 1411 Broadway. Completed in 1967, the open-plan space was anchored by a feature wall overtaken by an enormous, mural-size blowup of a Vera painting of happy suns rendered in black sumi-e brushwork. Mirrored walls lent a modern atmosphere, accentuated by sculptural furnishings: Herman Miller seating, an Achille Castiglioni Arco light, Breuer's own Wassily chairs, and a stainless-steel Jan Peter Stern piece from Vera's own art collection. Soft white flokati rugs softened the modern lines and bestowed a hint of 60s glamour to Vera's own office, kitted out with Japanese curios and a geometric Breuer wall-hanging. In the main sales space, racks of clothes were stashed behind floor-to-ceiling white draperies and displayed on triangular chromed partition walls.

Above, from left: Vera's first New York showroom, located at 417 Fifth Avenue, was designed by architect Marcel Breuer in 1952. She sold scarves and linens there on a wholesale basis. One wall was lined entirely in cork stoppers.

Opposite: Other walls of the showroom formed backdrops for painterly murals or Vera's collection of folk art, arranged on shelves. A Mexican candelabra she displayed there spawned a series of scarves showcasing its likeness.

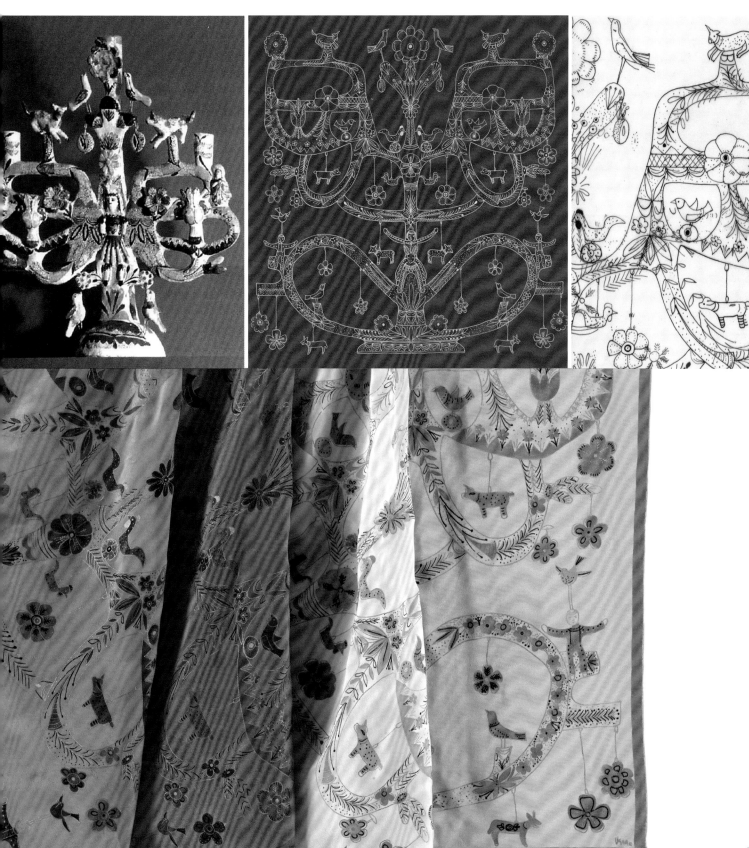

141

4

A Household Name

*"People want to feel or express emotions
in their clothes and furnishings.
A bland cocoon is a dull existence."*

—Vera

*A*lthough she is perhaps best known for her scarves, Vera's career actually began in textile design. After a brief postgraduate stint at a Seventh Avenue fashion house, she created fabrics and murals for children's rooms. In 1942, she left to launch Printex, where the first products were placemats. Her first order was from B. Altman; two years later, the company's first licensed product was a fabric and wallpaper line for F. Schumacher & Co.

Vera was a true pioneer in home textiles by manufacturing a comprehensive range of products—from bedding and towels to china and needlepoint pillows—and by introducing bright hues and modern patterns to categories where they were traditionally lacking. "The kitchen and bath were always the drabbest room(s) in the house," said Vera. "The poor woman at home all day—she just had to have some color. Even just with a bright-colored apron."[87] Some of her most popular creations were workaday items like calendar towels and whimsical linen dishcloths printed with jelly jars. "There are lots of women who only know the name Vera because some of her most unpleasant chores around the kitchen are made cheerier by the sudden sight of a potholder making a gay little spot in the kitchen."[88]

Vera swapped out her own linens numerous times a year so she could test out her designs and fabrics, and so she could truly enjoy them. "If you don't change the art around you, it becomes less important to you. After a while, you don't see it at all."[89]

The company also promoted handbooks in its showrooms and sales floors to teach customers how to mount and frame their Vera scarves to create inexpensive yet impactful artworks, a decorating trick that effectively bridged the fashion and home divisions.

Household objects and furnishings were a favorite Vera theme.

The kitchen

Vera's very first design was for a placemat, and she remained loyal to the medium. Indeed, the small format encapsulated two of her ideals: The shape was akin to a painting canvas, yet they were also objects that users could interact with intimately on a daily basis. It was the ultimate high/low accessory. Over the years she expanded the fabric offerings to include cottons, linens, polyester blends, permanent-press soil-releasing Belgian linens, and even easy-to-clean vinyl for outdoor dining. She and her creative teams envisioned myriad kitchen accessories, too: "As for that first placemat, it has grown into a whole Vera division of prints for the home: tablecloths, placemats and napkins, cocktail napkins, aprons, pot holders, toaster covers, and lots more," noted a 1960s press release. Her home collections ultimately comprised lines marketed under the Vera, Tabletrends, and Table Wear labels.

Vera saw the tabletop as a colorful painting, and developed a wardrobe of coordinating items. A how-to brochure called, appropriately, *The Art of the Table*, offered style guidance: "Treat a tabletop like a canvas," it advised, suggesting simple ideas for creating geometric tableaux by lining up square place mats of varying colors on a contrasting tablecloth. Another look could be achieved by setting printed vinyl placemats atop a tablecloth that matched the background color. Advice extended to centerpiece designs. Even bunches of carrots, the brochure suggested, could create a jaunty (and inexpensive) look. Vera's savvy marketing department also offered buyers endless ideas for napkin folding, from an elaborate fan to simple pleats placed in a glass like a bouquet of flowers.

These items were marketed to retailers at the Linens by Vera showroom at 417 Fifth Avenue; collections debuted during the thrice-annual market weeks. (A separate showroom sold solid-colored linens, which constituted a generous portion of the business but were not manufactured by the company; the designers shopped in Italian factories for fabrics.) Nancy Kristoff, who worked in linen sales from 1977 to the early 80s—a period when Vera's iconic Flights of Fancy and Sunflower patterns were popular—describes the architecture's revolutionary look, designed by Marcel Breuer: "The showroom was so contemporary and state-of-the-art. It was all mirror and glass. There was no product out—it was all stored in cubbies hidden behind partition walls. Placemats were laid on specially designed shelves, and tablecloths draped over these high Lucite tables. It was a process—everything was presented in a certain formal order. We never previewed items until market week, so there was a real element of surprise. It's a reminder of how adventurous we were at the time."

Gretchen Dale concurs: "What Vera designed was revolutionary; now we are much more conservative than she ever was. The 1960s and 70s was a great moment for tabletop; the business was receptive to new ideas. Retail was starting to become theater. Burdine's, May Co.—everyone wanted to outdo one another, to compete to be the first to get our designs."

Opposite: A festive strawberry print was translated into napkins and tablecloths.

Overleaf: Vera's vinyl placemats were suited to indoor or outdoor use. They often depicted botanical imagery, such as poppies and sunflowers.

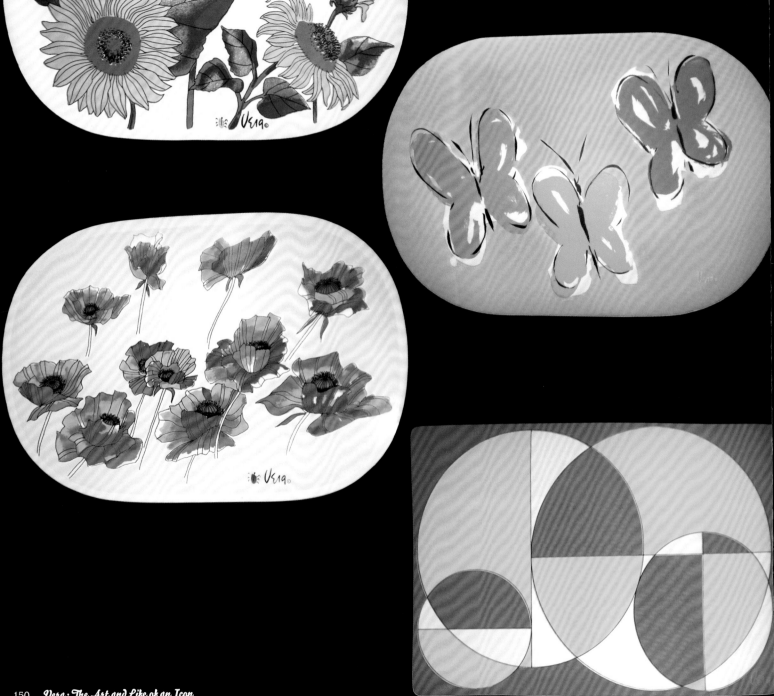

whole nutmeg bay leaf dill

parsley thyme cloves whole pepper

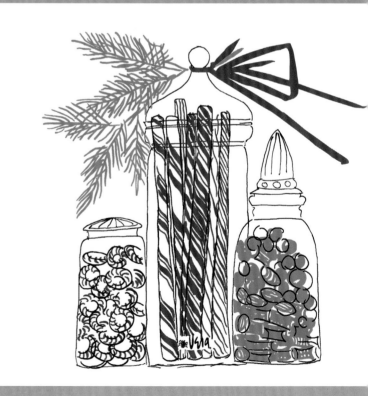

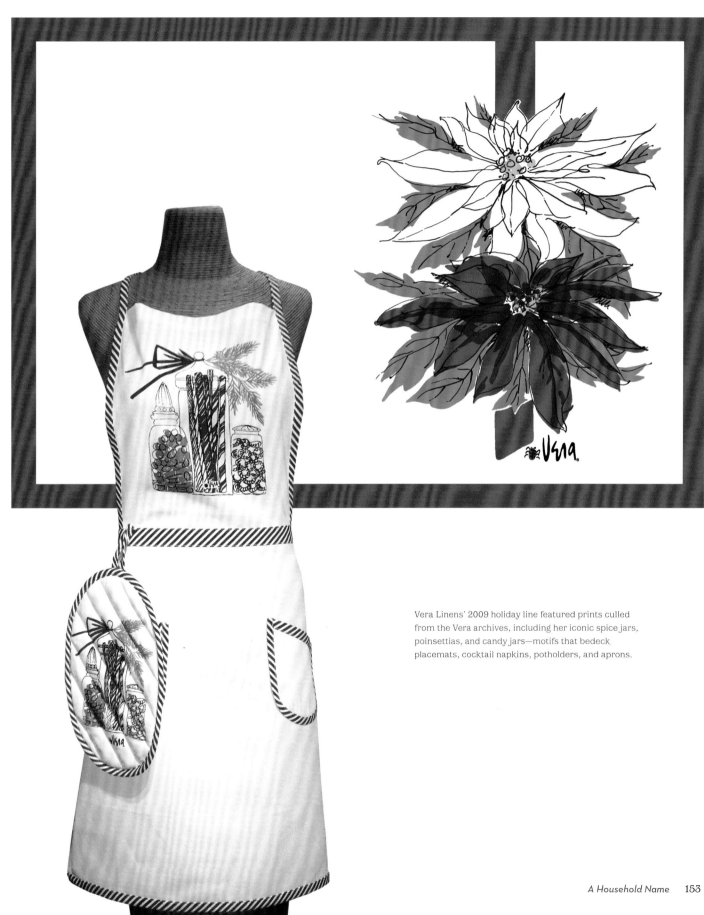

Vera Linens' 2009 holiday line featured prints culled from the Vera archives, including her iconic spice jars, poinsettias, and candy jars—motifs that bedeck placemats, cocktail napkins, potholders, and aprons.

Wallpaper and upholstery

Vera's first licensed products were for the home: wallpaper and textile patterns for F. Schumacher & Co. She connected with the company when director of merchandising René Carrillo visited the Printex studio in Manhattan and placed a large order. The result was her chinoiserie-inspired Tibet pattern in 1947, the same year her Gold Coast collection debuted. Shortly thereafter, she began designing similar patterns for Scalamandré and the Greeff Company.[90]

Over the years she designed numerous print and woven textile patterns, many sold alongside companion hand-printed wallpaper patterns. These included her 1949 fern print Jack-in-the-Pulpit, installed in the Truman White House. One of Schumacher's most popular patterns, it remained in production until 1986, and was updated slightly by Vera in the 70s, when she reestablished ties with the company. Her last collection for Schumacher was released in 1979.

Vera aspired to democratize fine art by bringing original designs to everyday household products like bedding and wallpaper, but when it came to creating textiles, she worked somewhat in reverse. "We frame a piece of the drapery being designed and put it up on the wall."[91]

Left, clockwise from left: Among Vera's popular textile designs for F. Schumacher & Co. were Papaya; Tibet (her first, from 1947), hand-printed on Aralac; and her 1979 design, Birches.

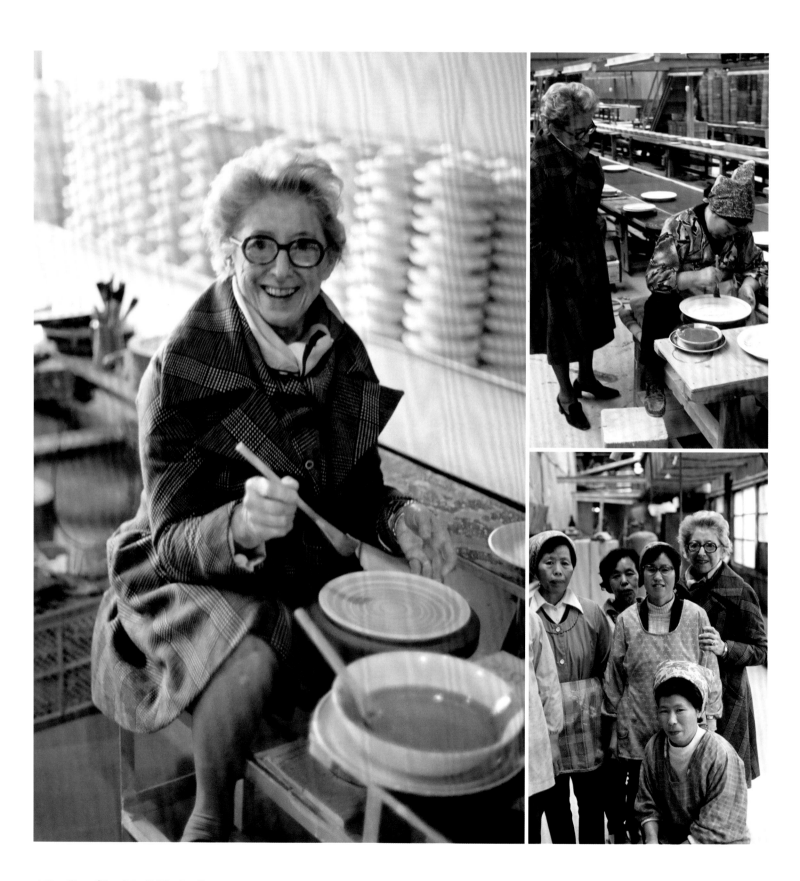

The dining room

Vera first licensed tabletop designs to Island Worcester, which produced hand-painted porcelain dishware in Jamaica. Later, in the 1960s, she began designing bone china dishes, serveware, and accessories for Mikasa, which were manufactured in Japan. Her most popular patterns were those embellished with graphic images of butterflies, apples, and her signature bright orange poppies.

The designer favored china at home and at work. She was famous for having family-style sit-down lunches in the studio and showrooms, completed with formal tableware. "I remember the amazing lunches," says Kimiko Matsuda. "The table was always china—even for onion rings delivered from the deli downstairs." Joan Reil has similar recollections. "Whenever we'd visit Ossining for a design day, she'd greet us with cups of coffee in china mugs—never paper. She was classy." (Nancy Kristoff agrees: "A Styrofoam cup once appeared on the lunch table and she made this face like, 'I never want to see that again!'")

Opposite: Visiting the Japanese factory that produced her tableware for Mikasa, Vera poses with staff and tries her hand at pottery.

Above: She also designed apple and bamboo prints to enliven the company's bone china dinnerware. When creating designs for china platters, Vera would create original artworks on a round paper canvas to get the composition and proportions right.

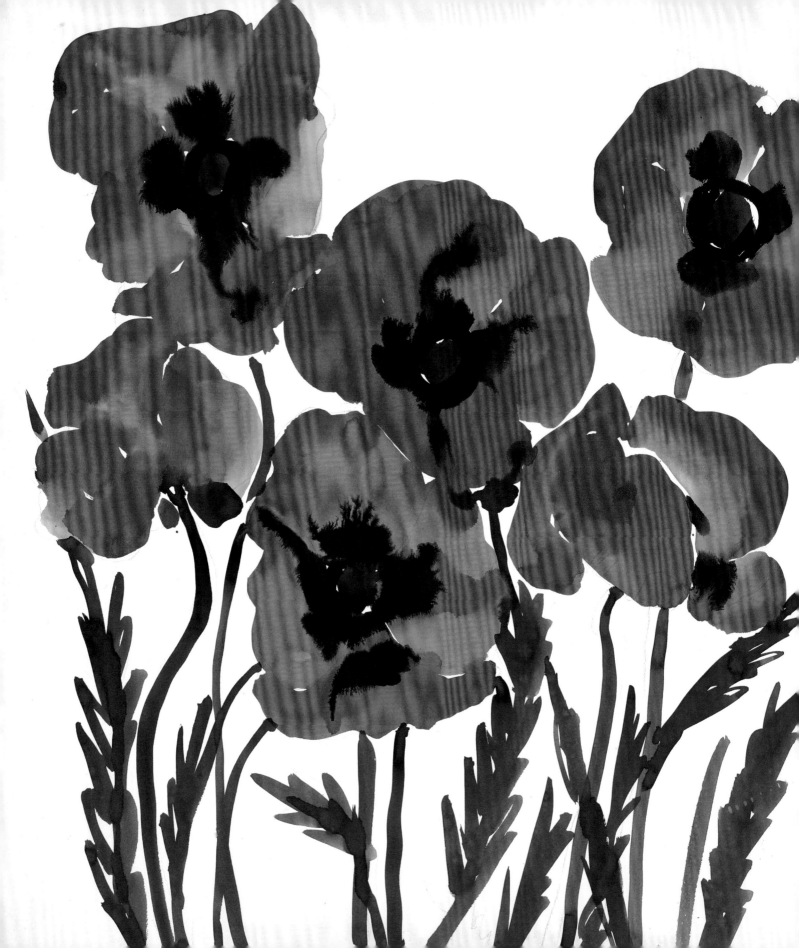

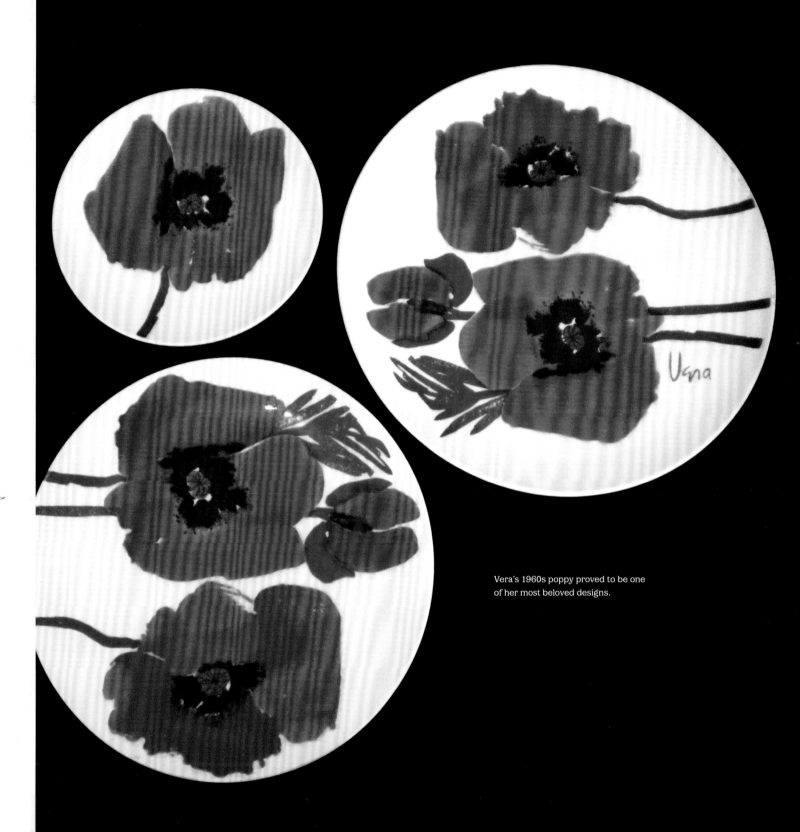

Vera's 1960s poppy proved to be one of her most beloved designs.

MEADOWFERNS

While some prints could be applied to everything from a dish towel to a dress, many were specific to a particular product category. "I couldn't use a string-of-garlic print for dresses, but it was great for kitchen accessories," Vera noted.[92] *Her popular Meadowferns motif was one of the most versatile patterns. Over the years, it embellished everything from scarves to bone china vases and sugar*

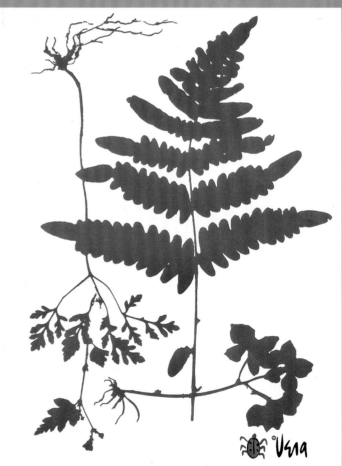

bowls for Mikasa to linen tea towels. Her famous Jack-in-the-Pulpit cotton chintz for F. Schumacher & Co. showcased an adaptation of this fern print. The pattern was based on a late-40s collage of greenery, plucked from the forest and taped to a paper background in a dynamic array. A 1950 article from the Valley Morning Star newspaper photographed Vera comparing one of

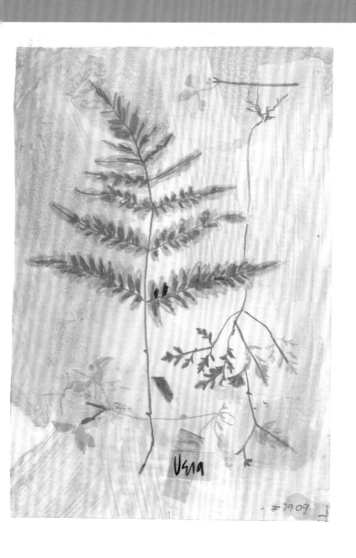

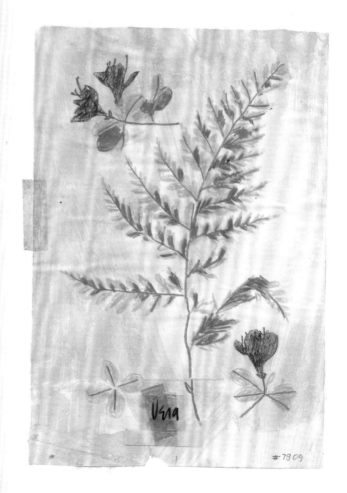

her final designs, a silk scarf, with its source material, scrutinizing the results to make sure it adequately captured the beauty and composition of its natural inspiration. She was intimately acquainted with the plant's triangular, fragile form; her Breuer house had a fern garden out back.

Opposite: Linen tea towels embellished with Vera's Meadowfern print.

Left: A lush fern garden had pride of place on Vera's back patio.

Below: Vera's Meadowfern collection of bone china for Mikasa included a salt and pepper set, a creamer and sugar bowl, and a vase.

Overleaf: The inspirational fern in various stages from original art to film used in the printing process.

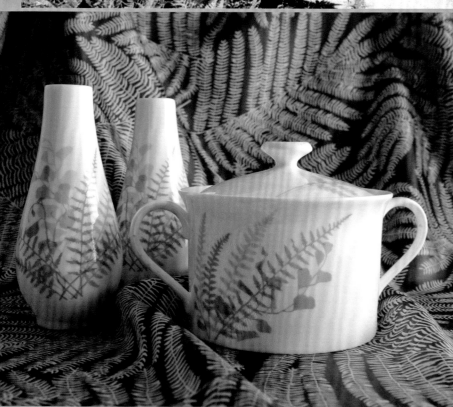

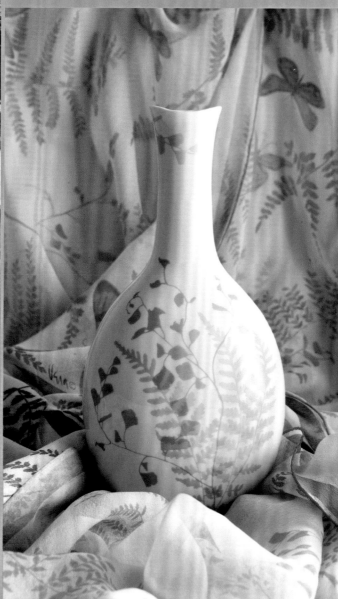

"NATURE OVERWHELMS ME CONSTANTLY." —VERA

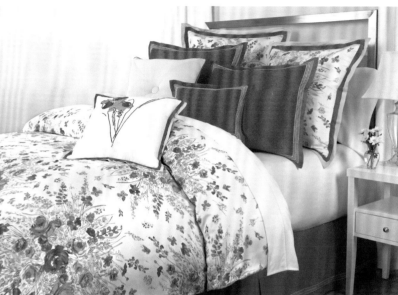

The bedroom

Burlington Industries introduced Vera's inaugural bedding line in 1969. She created sheets and pillowcases as well as towels and shower curtains. Like all her textiles, the patterns sprung from an original Vera. "She painted patterns to scale on a giant piece of paper laid on the floor," recalls Gretchen Dale. "It was the funniest thing in the world to watch." True to her aesthetic, Vera dreamed up linens splashed with bright hues and geometric designs like stripes and polka dots and dynamic color fields in addition to watercolor-inspired botanicals. Vera was credited with popularizing the trend for printed bedsheets;

fashion designers Yves Saint Laurent and Bill Blass soon followed her lead.

In the early 1970s, she introduced bedspreads and coordinating drapes; Lisbon Square was among the patterns available. The suite offered customers a way to coordinate the look of the whole room, not to mention the entire home.

Opposite: A Spring 2010 showroom poster displaying the original art for the Rose Bouquet bamboo bed.

Above: Vera's signature collection of bamboo bedroom linens. She was the first to bring lively colors and patterns to bedding, in the late 1960s.

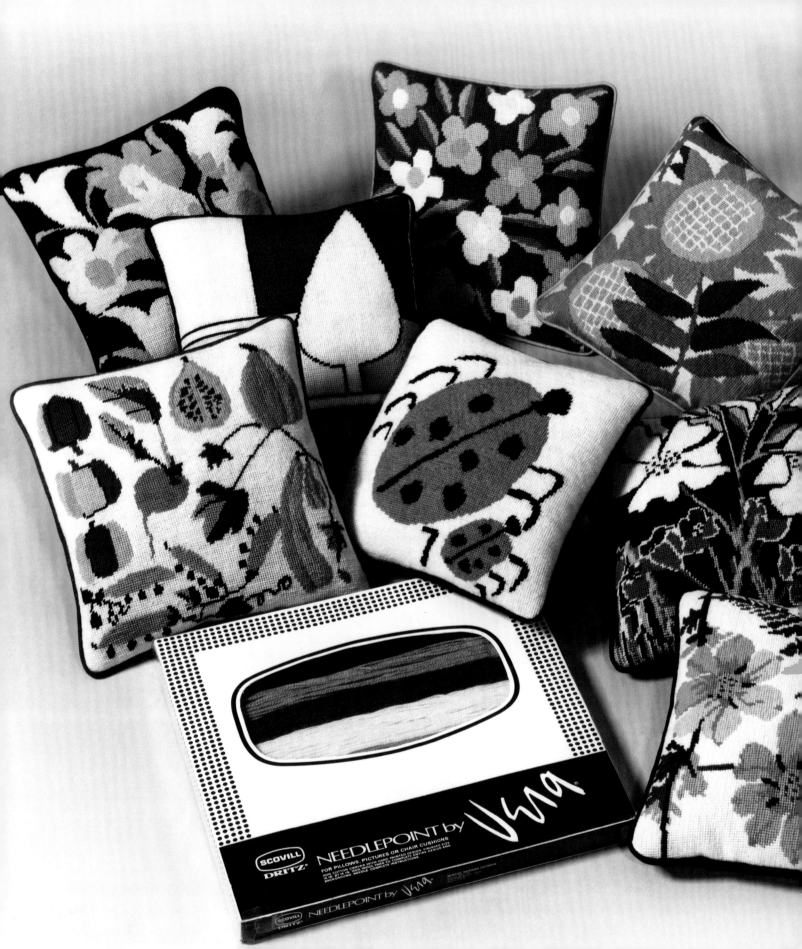

NEEDLEPOINT by Vera

SCOVILL DRITZ

FOR PILLOWS, PICTURES OR CHAIR CUSHIONS
100% COTTON CANVAS WITH HAND PAINTED DESIGN. FINISHED SIZE
14 IN. CUT 18 IN. WOOL YARN TO COMPLETE ENTIRE DESIGN AND
BACKGROUND. NEEDLE. COMPLETE INSTRUCTIONS

NEEDLEPOINT by Vera

Needlepoint

Vera's needlepoint collection for Dritz-Scovill debuted in June 1971. The whimsical line comprised ten hand-printed Vera designs, including sunflowers, Persian gardens, and ferns. Each canvas was 14 inches square, so it could be used as a throw pillow or hung on the wall like a painting. A second collection launched the following year offered more varied shapes and sizes: canvases up to 3 by 5 feet to be used as wall hangings or rugs. Stylized flowers, vegetables, and greenery were joined by abstracted prints like blazing Indian suns and Portuguese boats, and, of course, her signature ladybug.

5

A Passport To...

*"It doesn't matter where I go so long
as I break my routine and see new things."*
—Vera

Vera crisscrossed the globe to gather inspiration, ideas, and images to fuel her artwork and designs. She and George started traveling frequently in the late 1940s. Voyaging to destinations as diverse as Africa and China, the two would observe and document local rituals, customs, and craftsmanship they joyously discovered. "My husband would take photographs and I would grab up my little sketch pad," she told *The New York Times*.[93] Her copious studies would then be translated into patterns for the following season's scarves, tablecloths, and tunics. She would often sketch in transit; the view from an airplane window during a flight from Lima to Cuzco, Peru, sparked a sinuous geometric print that later bedecked a scarf and tunic—and the collection's promotional poster.

Vera paints Peru

paintings, printings, limited editions for fall THE VERA GALLERIES June 6th–30th, 1966

NEW YORK
417 Fifth Avenue

SAN FRANCISCO
321 Market Street

DALLAS
Dallas Apparel Mart

LOS ANGELES
110 East Ninth Street

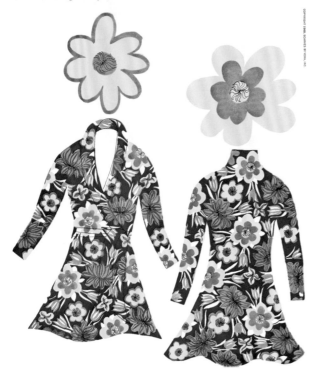

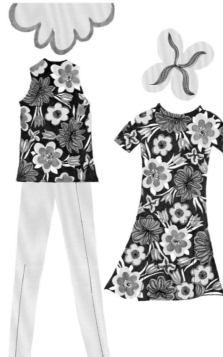

You're in Denmark.

It's spring.

Everything's in bloom.

Especially the flowers.

A camera just can't catch it. But an artist could. Someone like Vera. And it just so happens that Vera painted all the frivoli at Tivoli for you. Flowers. Butterflies. Pinwheels. More. Yes, Vera's paintings take off from Denmark this spring and land in Ban-Lon® shapey shifts and tops and pants of DuPont nylon that stay flower fresh and carefree. So bloom from left to right. Look very thirties in a wrap shift $47. Whirl out in a turtle top shift $45. Have fun in a funnel neck top $15, over stovepipe pants $16. Skim along in a pocketed skimmer $36. All in sizes 8 to 18 in all Vera colors that look delightfully Danish. To bloom just zoom to Denmark via Vera at all the finest stores in the U.S.A. Prices slightly higher in the west. *Verascarves and Verawear for you, Veralinens for your home.*

THE VERA GALLERY
417 Fifth Avenue, New York 10016

Vera paints Denmark in bloom on a Ban-Lon® field of DuPont nylon

If Vera saw a minaret in Montana, she'd paint it. So why not a pony in Persia? Not just any pony, but a Vera pony and just one of her many, many versions inspired by the Persians and done in Minicare cottons for you. There are tunics, shirts and shirtshifts and so on and on including Vera's very own super superb

Ban-Lon® pants of DuPont nylon

Come see her whole Persian Garden Collection with Mosques. Minarets. More. $16 to $30 in sizes 6 to 18 at the finest stores from here to Persia. Silk streamer scarf $5. Prices slightly higher in the West.

THE VERA GALLERY
417 Fifth Ave., N.Y. 10016.

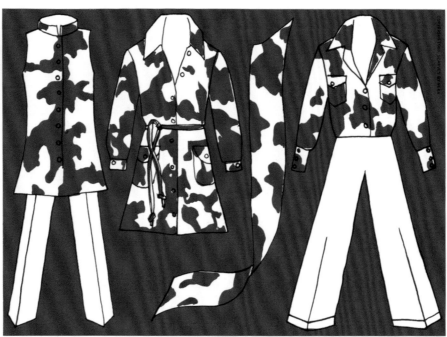

Vera paints a Persian Pony
in Minicare® cottons for, you know, mini care

After George's untimely death, Vera continued to globetrot. Sometimes she brought along a business associate such as her right-hand man and studio artist Walter Erhard or her vice president of production Marvin Pelzer, with whom she traveled to China to produce a collection of silk scarves in 1974. Other times she journeyed alone. She always traveled in style, packing Vera scarves and sportswear alongside her art supplies.

Along the way, Vera collected tchotchkes and folk art, from Danish licorice to Pakistani textiles. An off-the-beaten-path local market was always her first destination. "I rarely go where the tourists are," she said. "I find the folk art usually from word of mouth. Most of the people think I am a little bit wacky, so they'll let me through."[94] Bringing home cultural artifacts allowed continued exploration upon her return and at a more leisurely pace. Once back

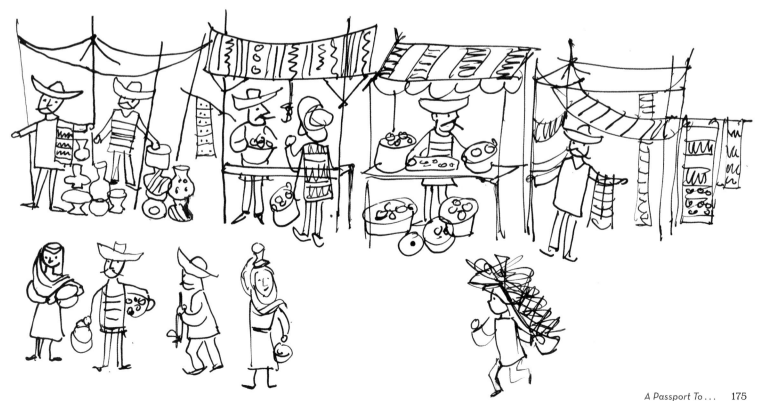

"In Persia," says Vera, "gardens aren't the only thing that are gardens. Rugs are gardens. Tiles are gardens. Bazaars are gardens. Arcades are gardens. Even a drop of perfume is a whole garden of roses." And now you can enjoy Vera's garden as well as all her other versions inspired by the Persians. Mosques. Minarets. Mountains. More. All on great things for you to wear. Like the Persian Garden scarf of silk $5. The hooded midriff topping generous pants. And since it's pants, pants, pants this year, keep going with the tunic over flared pants of Trevira® polyester knit. Or the Persian Tile jacket and bra mixing with jeans. All in Minicare® cottons except where noted. All in Vera colors with no exceptions. $8 to $22 in sizes 6 to 18 at the finest stores between you and Persia. Prices slightly higher in the West. THE VERA GALLERY
417 Fifth Avenue, New York, 10016

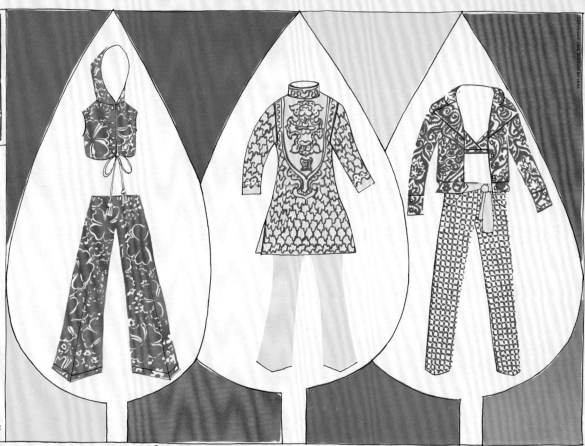

Vera Paints a Persian Garden

in Ossining, Vera surrounded herself with her souvenirs, taking a closer look at their visual characteristics. Trinkets were not the only items she brought back. From Denmark, the subject of her fall 1968 Danish-To-Go collection, Vera imported the Royal Danish Orchestra, who performed at the New York launch party.

Vera's insatiable curiosity took her everywhere, from Budapest to Morroco to the Greek isles, which inspired her 1966 Clothesopolis collection. In Iran, she became enamored of the exotic flowers in Persian gardens, reflected in her spring 1968 line. Rough-hewn Mexican pottery and Navajo blankets guided the Indian Spirit line. A trip to Brazil the following year provided an opportunity to observe Oscar Niemeyer's tropical modernist architecture in Brasília, whose voluptuous forms she translated into vibrant scarves. Her fall 1972 Evening in Yugoslavia collection captured the wild beauty of the Adriatic coast.

She was not only inspired by motifs and colors, patterns and materials, but also by sartorial habits. Peruvians' use of head coverings was the impetus behind her invention of the Verabout, designed to be worn as a head scarf. Macedonian-style embroidered vests appeared in her Yugoslavia line. Her Maharanee pajamas from 1969 riffed on traditional Indian harem pants.

If Vera didn't know the dialect spoken in a certain locale, she had a little help: The ladybug means "good luck" in every language.

Left: Intricate paisleys and miniature flowers dance across an Iranian-themed scarf.

NORTHWEST INDIAN - HAIDA TRIBE

MEXICO

Vera's travels across Mexico and South America inspired her 1971 Indian Spirit collection, based on indigenous local craft traditions she discovered, from God's Eye wands and totems to the fluid lines of a Makah tribal dancer.

a visit with Vera…

in her studio…

◄ "The collage design shown here was inspired by the woven God's Eye wand I saw Mexicans carry on Festival days".

Question Vera and you receive very Vera answers.
"How would you describe yourself, Vera, to someone who didn't know who you are?"
"I'd say I'm an artist who prefers to paint things for people rather than for walls. So I turn my paintings into things people wear or use. Scarves, blouses, sportswear, fashions for the home".

"How do you turn paintings into things to wear?"
"I start by painting what I like. Bunches, apples, geometrics. My canvas is registered in the Library of Congress as a work of art. Then it's silk-screened by hand onto fabric. The fabric becomes a blouse, a dress, whatever."
"Your'e always doing something different. What inspires you?"
"Everything I see wherever I go. For example, I spent weeks in the many Americas and fell in love with Indian life and art. Result: My new collection is called 'Indian Spirit.' "

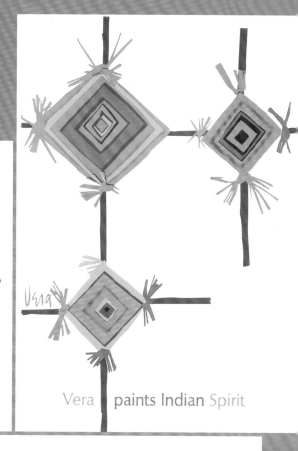

Vera paints Indian Spirit

"A detail from an Indian scene was painted by a native artist about five centuries ago. It inspired me to paint my geometric 'Tepee', in an abstract mood".

"I found the Indian art of South America highly stylized and loaded with symbolism. I simplified their symbol of 'Man' to create my 'Totem' scarf design".

"In Mitla, Oaxaca, I admired a decoration on a stone wall. I must have carried the idea home in my mind's eye, because it landed on my 'Indian Blanket' scarf".

"A Makah tribal dancer wore a ceremonial robe with an Indian Blanket motif. I used the swirl in my 'Northwest Indian' scarf, and my blouses, tunics, dresses".

Vera paints Indian Spirit in scarves, sportswear, fashions for the home.

Vera

Only a flower can understand
the language of the rain and snow.

Alice Siegel

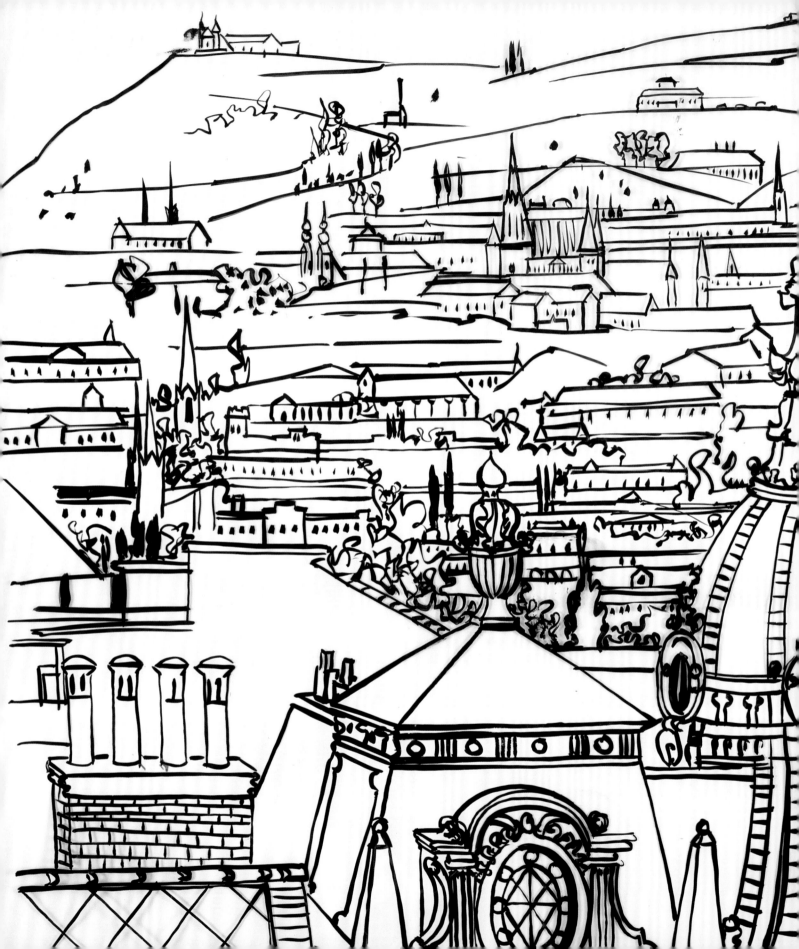

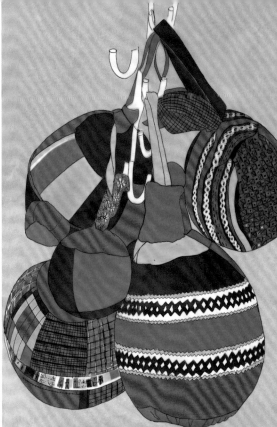

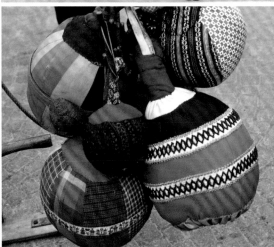

AUSTRIA

Austria, husband George's homeland, brought a smile to Vera's face. In the town of Imst, she attended the Imster Schemenlaufen festival, held every four years celebrate spring's victory over winter. The woven bags are a feature of the festivities.

Opposite: A photograph of a broken tile mosaic, snapped during a trip overseas, inspired the graphic pattern of these silk scarves.

AFRICA

The Neumanns first voyaged to Morocco in 1961. While George surveyed the country through his camera lens, snapping architectural details, native flowers, and artisanal crafts, Vera captured the same imagery in watercolor. Visions of whitewashed buildings against searing azure skies left an impression, working their way into her scarf and sportswear collections the following season. A *New York Times* article covering the press preview described her fashions showcased alongside the source material that inspired them, including "Arab mantels, primitive wooden locks, and crude tableware."[95]

Vera enjoyed Africa so much that she returned for a repeat visit in the 70s with Walter Earhardt. This time she brought back carved-wood war masks and a fondness for citrus hues paired with purple.

Below left: African war masks were among the folk art Vera collected while traveling the continent.

Opposite, top right: Shopping in a Moroccan bazaar.

Opposite, bottom right: A composition of African spears animates this 1971 strike-off for a scarf design.

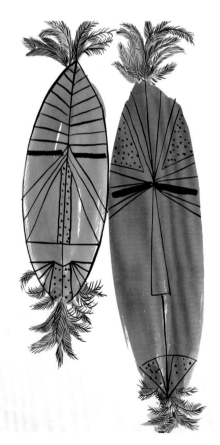

INDIA

At the invitation of Air India, Vera jetted to Bombay and Agra, resulting in her color-drenched fall 1969 Jewels of India collection. Intricate paisleys, heavy ornamentation, and intense saffron and violet hues influenced the lush palette of her scarves, sportswear, and linens. Vera marveled at the pageantry of the country's sporting culture, from polo games to tiger hunts, and the elaborate Islamic architecture of the Taj Mahal. Her documentary-style photographs of turbaned gentlemen, blanket-berobed elephants, bejeweled young girls, and sari-clad women cooking complex curries were included in sales and press kits promoting the collection. (They were also made available to retail partners for inclusion in their visual merchandising programs.)

The trip proved wildly inspiring. As the marketing materials explained, "I don't think (Vera) has ever been more deeply moved by any of her trips. And, frankly, I don't think we've ever had a more vibrant collection, or one so full of new ideas. India is unique. Because it is one of the few countries that hasn't been promoted to death, India offers an exciting springboard for fashion and promotion ideas." Vera captured the texture and flavor of the country's inhabitants by mimicking the forms of their traditional garb; flowing saris, harem pants, and chadors appeared alongside more Americanized novelties like "cordless" corduroys and sheared Vera-terry towels. She was also charmed to witness the early effects of globalization: Indian girls wore their scarves long and skinny, a trend started by Vera herself, halfway across the globe.

Vera paints the Blaze of In

SCARVES BY VERA

Vera paints the Blaze of India, then makes it into sporting ideas for you to wear. Safari-pocketed shirt shift that's sashed with fringe and buttoned with Vera's own signature buttons, in Orlon® acrylic challis, $35. The vibrant top with signature cuff links, in cotton twill, $20. Ban-Lon® pants are tailored by Vera to that typical Vera faultless fit. $16 the pair. Tunic buttoned with miniature mirrors, in Orlon acrylic challis, $27. Everything sizes 8 to 18. Silk twill scarf, inspired by the painting on the easel, $5. Prices slightly higher in the West. See the rest of what Vera found in India. Vera's whole India collection now flying into fashionable stores.

VERA PAINTS
THE JEWELS OF INDIA

Recently Air India invited Vera to spend a few weeks as their guest.

Vera went to India and I don't think she has ever been more deeply moved
by any of her trips. And, frankly, I don't think we've ever had a
more vibrant collection, or one so full of new ideas.

From a store's point-of-view, too, India is unique. Because it is one of the
few countries that hasn't been promoted to death,
India offers an exciting new springboard for fashion and promotion ideas.

Here, let me show you what I mean

VERA PAINTS
THE FRINGES OF INDIA
For your fringed tunic presentation, a fringed
elephant photo to blow-up as a window
backdrop is available.

In India, Vera became entranced by the culture's exuberant
ornamentation and elaborate costumes. Her photographs helped
promote Jewels of India in stores.

VERA PAINTS THE BRILLIANCE OF A MAHARANEE'S JEWELS

The jewel colors of India blaze on Vera shirts, tops and pants. A black and white photo of the India background is available to you for blow-up use in window displays.

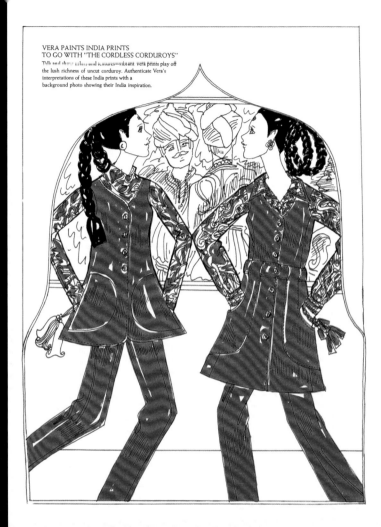

VERA PAINTS INDIA PRINTS TO GO WITH "THE CORDLESS CORDUROYS"

Tolk and showy colors and textures—vibrant Vera prints play off the lush richness of uncut corduroy. Authenticate Vera's interpretations of these India prints with a background photo showing their India inspiration.

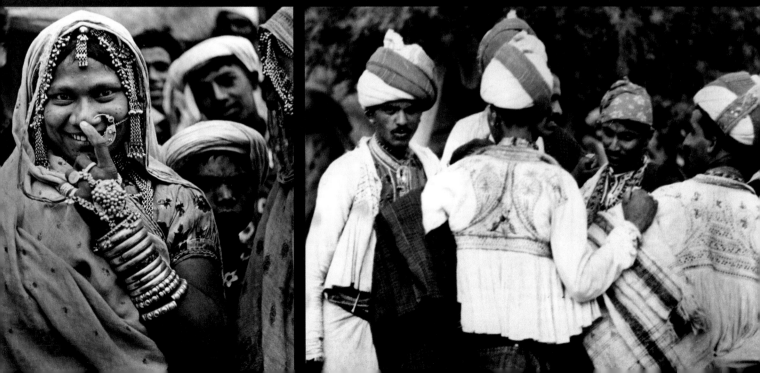

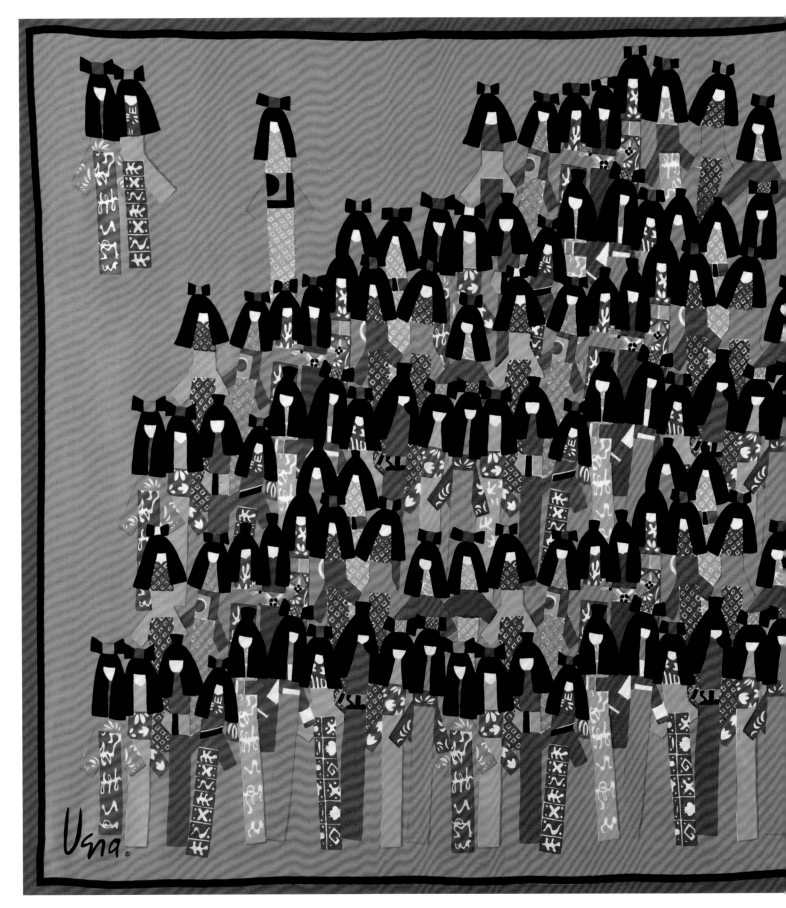

THE ORIENT

Vera's imagery was greatly influenced by Asian motifs like cherry blossoms and calligraphy. Her fall 1965 Fan T-Asia line, colored with vegetable dyes, was inspired by the continent's rich cultural output. From Hong Kong to Taiwan, this part of the world was a favorite destination. "I think once, in one of my incarnations—if you believe in that—I must have been Oriental," Vera noted.[96] In Japan she perfected her sumi-e brushwork technique and mingled with geisha girls, whose elaborate, formal costumes she depicted in a series of scarves.

But it was her Chinese adventures that made history. Vera had long wanted to go there. "I've seen scarves from all over the world but none have had the perfection of the Chinese scarves," she said. "I thought it would be a great coup (to have scarves made there)."[97] Vera got her wish in 1974, after applying to visit with Marvin Pelzer, VP of production, who had lived there previously. "We never heard a word," Vera said. "Then we got a cable to come in January 1974. It was late December. We couldn't make plans that fast, but we did go early in February. That's when they decided that we could have our things done there if we wanted to."[98]

In Shanghai they toured a folk-art school, a museum, a department store, and silk manufacturing plants, which they discovered were quite modern. The artisans' aesthetic sensibility, though, tended to be a little more traditional. Vera described the Chinese response to her paintings on which the collection would be based. "They looked at them and said very politely that the lines were very free and did I want to fill them in. I said 'no' and they, again, very politely left them the way they were."[99]

According to Nicholas Ludlow of the National Council for United States–China Trade, the collaboration marked the first time that American designs were

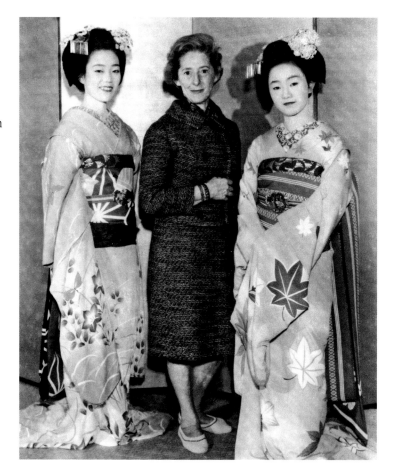

produced in the People's Republic of China for sale in the United States. "It's a major breakthrough," he told *The New York Times*.[100] Plum blossoms and cloisonné-inspired prints were among the eight scarf designs, which debuted that fall,[101] all finished with hand-rolled edges. She sold them at a slightly higher price point, $12 instead of $10. They were signed with the name "Vera" in English below the Chinese characters for truth and honesty. She would follow it up with a second line for fall/holiday 1976, this time bringing her own color separations and screens on the plane.[102]

Opposite and above: During a visit to Japan, Vera poses with geisha girls in full regalia. She captured the stylized ornamentation and rigorous silhouettes of their kimonos—works of art themselves—in watercolor and paper-collage studies and, later, a series of scarves.

Overleaf: Banner kites and steamer baskets became fodder for Vera's artwork.

SCANDINAVIA

Vera's voyages to Scandinavia were fruitful, inspiring two inventive collections. Copenhagen's Tivoli Gardens sparked Danish-To-Go in the fall of 1968. And the dramatic beauty of Lapland led to the Midnight Sun collection the next year. In this northernmost tip of the world, Vera observed members of the nomadic Lapp tribes smoking pipes, furnishing tents with soft fur rugs, and riding reindeer, animals who provided all aspects of daily living: transportation, sporting, and nourishment. She loved the muted brown of their speckled fur and the abstract curve of their antlers, which became a motif for her scarves.

Vera noted the short summertime's effect on plant life. "What a strange land!" she wrote. "Nature compresses its growing season in a concentrated blaze of intense color, particularly the brilliant reds and golds, which fade away and die quickly in the grip of frost and wind. I tried to make the color last longer by putting it in my designs." She interpreted the flowers, birch trees, and distinctive herbs into designs for tablecloths, place mats, and aprons.

Less ephemeral objects like pewter knife sheaths and seafarer's hats inspired other designs. The prow of a Viking ship sailed across a silk scarf. A peasant blouse mimicked a Lapp lady's tunic, whose bright primary hues were a means to counter winter's oppressive darkness. One woman bequeathed Vera her animal-bone shuttle, which the Lapps used for weaving on primitive looms.

The collection's signature motif came not from a direct observation, but from Vera's own active imagination. After traveling so far north to catch a glimpse of the famed midnight sun, a heavy cloud cover blocked her view, so she made a painting of what she thought it might look like instead.

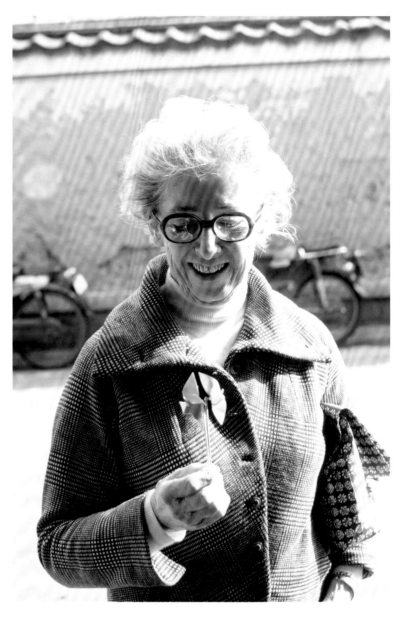

Above: While touring Scandinavia, Vera found herself entranced by the pinwheels at Tivoli and used the motif on everything from scarves to blouses. "Tivoli spelled backwards is, *I love it*," Vera noted.

Opposite: An advertisement announcing the 1968 Danish-To-Go collection.

If you can't go to Denmark right now, you simply must have Danish to go: Vera's new collection instigated by all the frivoli at Tivoli. Yes, Vera loved Tivoli Gardens and, being Vera, she didn't just look. She painted. And painted. Non-stop. Because everything at Tivoli is going somewhere. Even if it's around in circles. Roller Coasters. Sparklers. Bubbles. Targets. Spinning Lights. Her pinwheel is just part of the goings you should have on. So, ready, set, go Danish to go with everything inspired by Denmark including a cotton duck top $15, going over Ban-Lon® shorts of DuPont nylon $13. Or a pure silk shirt $27, with Ban-Lon® pants $16. Or a silk pongee shirt $18, topping a long wrap skirt in a rich sweep of primaVera double knit acetate $33. Or a cotton duck dress with belt going empire $25. Almost all in sizes 6 to 18. And overhead, the 28" square silk twill signature scarf $5. All in Vera colors which have gone delightfully Danish. Go to Denmark via Vera at all fine stores in the U.S.A. Prices slightly higher in the west. *Tops, pants, shifts, scarves, linens for your home and more by Vera.* THE VERA GALLERY, 417 Fifth Ave., N.Y. 10016

Vera paints Danish to go

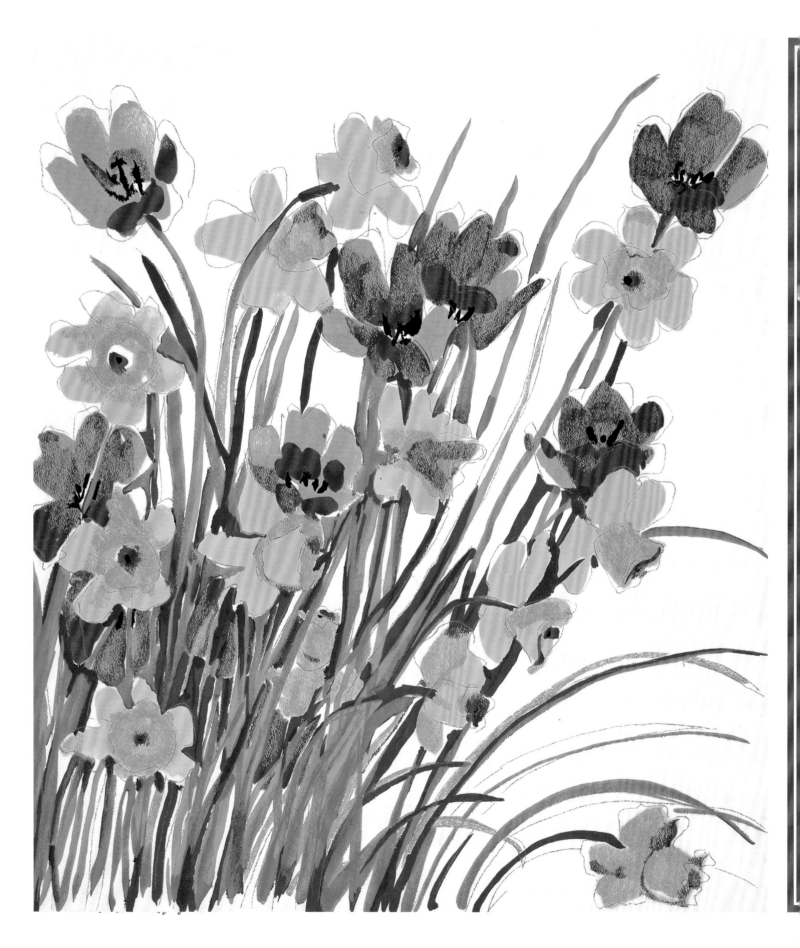

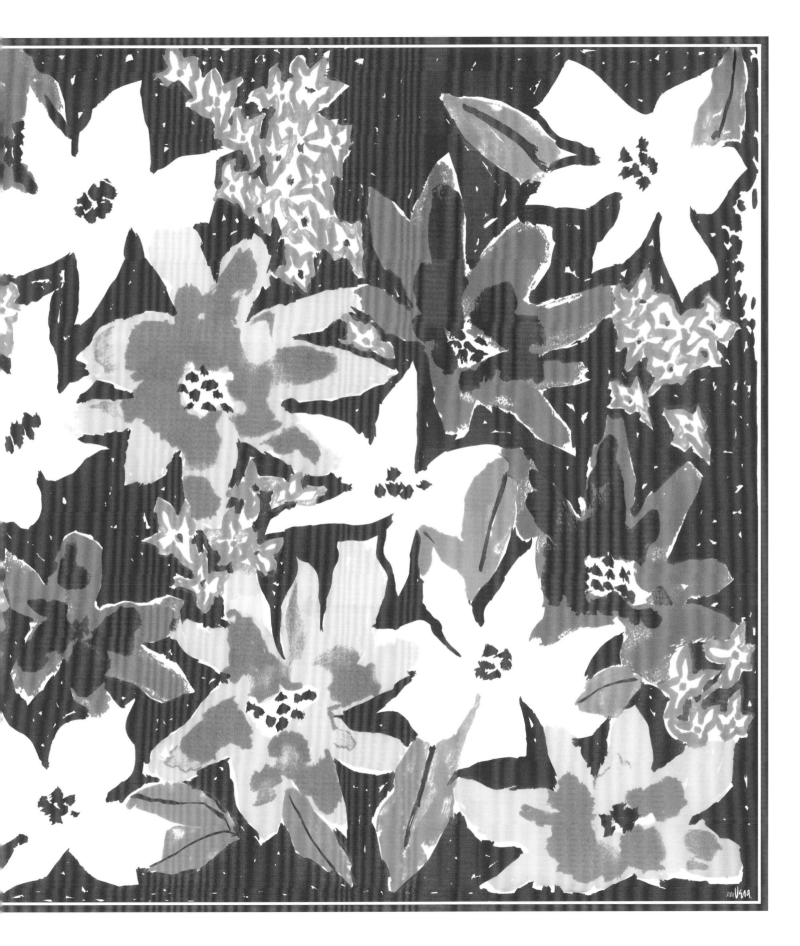

Bibliography

BOOKS

Barmash, Isadore. *The Self-Made Man.* The Macmillan Company, 1969.

Gatje, Robert F. *Marcel Breuer, A Memoir.* Monacelli Press, 2000.

Jackson, Lesley. *Twentieth-Century Pattern Design.* Princeton Architectural Press, 2007.

Kirkham, Pat, ed. *Women Designers in the USA: 1900-2000.* Yale University Press, 2000.

Michalets, Jeanette and Katherine. *Vera Textiles: Add Color to Everyday Fashion.* Schiffer Publishing, 2006.

Rich-McCoy, Lois. *Millionairess: Self-Made Women of America.* Harper & Row, 1978.

Slavin, Richard E. III and Jane C. Nylander. *Opulent Textiles: The Schumacher Collection.* Crown Publishers, 1992.

Stern, Bert and Annie Gottlieb. *The Complete Last Sitting.* Schirmer Art Books, 2006.

FILMS

In the Company of Vera, by Fred Salaff, 1976.

Vera Paints Ibiza in the Sun, by Fred Salaff, 1972.

ARTICLES

"A Designer for Just Three Years, He Has the Look of a Winner," by Anne-Marie Schiro. *The New York Times,* May 15, 1978.

"American Designer Scores First With Scarves Made in China," by Mary Campbell. *Casa Grande Dispatch,* August 26, 1975.

"Art on Wheels," by Jan Biles. *Journal-World,* June 29, 1997.

"Breuer on Broadway." *Interior Design,* October 1970.

"Breuer-on-Hudson," by Carol Cooper Garey. *Home Finishings Daily,* July 6, 1967.

"By Vera, Inspired In China," by Enid Nemy. *The New York Times,* June 19, 1975.

"Chinese Silk Scarves: Vera's Anniversary Design," by Mary Campbell. *The Free Lance-Star,* August 2, 1975.

"Contemporary, and Historic," by Souren Melikian. *International Herald Tribune,* November 13, 1993.

"Designer Coordinates Colors to Wear Together." *Boca Raton News,* June 22, 1976.

"Designer Scarves Join Name-Dropping Game," by Bernadine Morris. *The New York Times,* February 12, 1966.

"Designer's Studio is for All Kinds of Folks," by Georgia Sauer. *Daily News,* October 17, 1975.

"Give the Little Girl a Great Big Towel," by Olga Curtis. *Parade,* April 10, 1960.

"Golden Girl," by Alex Tresniowski. *People,* August 16, 1999.

"Honesty Prodded Vera to Success." *The Milwaukee Sentinel,* September 21, 1977.

"It's As If Home's Décor Had Signature of Vera and A Ladybug Symbol," by Lisa Hammel. *The New York Times,* October 11, 1972.

"Kathleen Cleary is Bride." *Sheboygan Press,* August 24, 1972.

"Manhattan Shirt Adds Three to Board." *The New York Times,* June 28, 1967.

"Name Power: Still Pulling Numbers." *Home Fashions Textiles,* June 1980.

"New Lightweight Luggage Eliminates Baggage Lines." *St. Petersburg Times,* September 1, 1969.

"Old Quilt Patterns to Be Adapted to Scarves," by Anita Gold. *The Dallas Morning News,* January 31, 1987.

"Own Business." *Delaware County Daily Times,* September 13, 1977.

"Perry Ellis' Slouch Look, With Room to Think," by Nina S. Hyde. *The Washington Post,* March 10, 1978.

"Recognize That Painting? It May Be Your Vera Scarf," by Enid Nemy. *The New York Times,* March 31, 1970.

"Renaissance Woman Paints Daisies." *The Washington Star,* October 4, 1972.

"Salant Struggles After Acquisition," by Isadore Barmash. *The New York Times,* June 25, 1990.

"Scarf Looks Best if Worn Around the Neck," by Olga Curtis. *The Cedar Rapids Gazette,* December 25, 1955.

"She's No Wallflower at Decors," by Ellie Grossman. *Prescott Courier,* June 16, 1978.

"Sleeping Beauties," by Joan O'Sullivan. *The Daily News, Huntingdon and Mount Union PA,* September 17, 1971.

"Strictly American Beauty Made in Hudson Mansion," by Dorothy Roe. *Valley Morning Star* of Harlingen, Texas, October 30, 1950.

"The Female Factor: Vera." *Linens, Domestics & Bath,* June 1980.

"The House That Scarves Built," by Bernadette Carey. *The New York Times,* May 11, 1967.

"The Signature Market: For Designers, the Sky's the Limit," by Enid Nemy. *The New York Times,* July 2, 1969.

"The Total Sportswear Look by Vera," by Bernadine Morris. *The New York Times,* July 8, 1966.

"Those Colorful White Sales," by Herbert Koshetz. *The New York Times,* January 21, 1973.

"Trip to Africa Is Inspiration for Designer," by Rita Reif. *The New York Times,* March 27, 1961.

"Vera, 84, an Artist and Designer Famed for Her Signature Scarves," by Wolfgang Saxon. *The New York Times,* June 17, 1993.

"Vera and the Money Tree," by Gary Abrams. *The Los Angeles Times,* April 3, 1981.

"Vera Creates Pure and Simple Lines," by Sharon Cheswick. *The New York Times,* September 25, 1977.

"Vera Designs Yield $12 Million," by Isadore Barmash. *The New York Times,* April 27, 1968.

"Vera Neumann, Creator of Vera Prints, Dies at 84," by Amanda Meadus. *Women's Wear Daily,* June 17, 1993.

"Vera Neumann Pieces Show Her Distinct Identity." *Alton Telegraph,* April 3, 1984.

"Vera Neumann; Scarf, Sportswear Designer." *Los Angeles Times,* June 18, 1993.

"Vera Paints the Patterns of a Lifetime," by Ruth La Ferla. *The Dallas Morning News,* July 3, 1985.

"Vera, the Big Apple and Other Designs," by Nina S. Hyde. *The Washington Post,* October 4, 1972.

"Vera the Joyous is Honored by the Smithsonian," by Nora Hampton. *The Oakland Tribune,* November 16, 1972.

"Vera to Receive Camellia Award," by Mildred Whiteaker. *The San Antonio Express-News,* January 30, 1966.

"Vera Tries Talented Hand at Luggage," by Bernadine Morris. *The New York Times,* August 29, 1969.

"Vera's Her Name and Color's Her Fame," by Stephanie Mansfield. *The Washington Post,* May 28, 1978.

"Vera's New Verve," by Marian Christy. *The Oakland Tribune,* June 13, 1970.

"Where Art and Technology Merge," by Stanley M. Suchecki. *Textile Industries,* August 1966.

"Yugoslavia is Inspiration for Vera's New Collection." *The Fresno Bee,* August 10, 1972.

AUCTION CATALOGS

Christies' "Personal Property of Marilyn Monroe." Sale, October 26, 1999.

Sotheby's Contemporary Art I, November 10, 1993.

Endnotes

1 *The Washington Post*: May 28, 1978.
2 Company literature.
3 Company literature.
4 *The New York Times*: September 25, 1977.
5 *The Washington Star*: October 4, 1972.
6 *The Free Lance-Star*: August 2, 1975.
7 *The Milwaukee Sentinel*: September 21, 1977.
8 *The Oakland Tribune*: June 13, 1970.
9 *The Oakland Tribune*: November 16, 1972.
10 *The Oakland Tribune*: June 13, 1970.
11 *The Oakland Tribune*: June 13, 1970.
12 *The Milwaukee Sentinel*: September 21, 1977.
13 *The Oakland Tribune*: November 16, 1972.
14 Company literature.
15 *The Oakland Tribune*: November 21, 1974.
16 *The Milwaukee Sentinel*: September 21, 1977.
17 *The Washington Post*: May 18, 1978
18 *The Self-Made Man,* Isadore Barmash (The Macmillan Company, 1969), page 300.
19 *The San Antonio Express-News*: January 30, 1966.
20 *The New York Times*: September 25, 1977.
21 *The Oakland Tribune*: June 13, 1970.
22 *The New York Times*: September 25, 1977.
23 *The Self-Made Man,* Isadore Barmash (The Macmillan Company, 1969), page 300.
24 *The Washington Post*: May 28, 1978.
25 *The New York Times*: March 27, 1961.
26 Per F. Schumacher & Co. archives.
27 *The Self-Made Man,* Isadore Barmash (The Macmillan Company, 1969), page 301.
28 *Opulent Textiles: The Schumacher Collection,* Richard E. Slavin III (Crown Publishers, 1992), page 177.
29 *Casa Grande Dispatch*: August 25, 1975.
30 *The New York Times*: March 27, 1961.
31 *Daily News*: October 17, 1975.
32 *Daily News*: October 17, 1975.
33 *The New York Times*: March 31, 1970.
34 *The Self-Made Man,* Isadore Barmash (The Macmillan Company, 1969), page 300.
35 *Valley Morning Star*: October 30, 1950
36 *The Albany Times Union*: July 14, 1972.
37 *Valley Morning Star*: October 30, 1950
38 *Home Finishings Daily*: July 6, 1967.
39 *The Oakland Tribune*: November 16, 1972.
40 *Marcel Breuer, a Memoir,* Robert F. Gatje (Monacelli Press, 2000), page 43.
41 Company literature.
42 *Sheboygan Press*: August 24, 1972.
43 *The Oakland Tribune*: June 13, 1970.
44 Sotheby's auction records.
45 *The New York Times*: March 27, 1961.
46 *Parade*: April 10, 1960.
47 *The Washington Post*: May 28, 1978.
48 *Personal Property of Marilyn Monroe* catalogue.
49 *The Milwaukee Sentinel*: September 21, 1977.
50 *Millionairess,* Lois Rich-McCoy (Harper & Row, 1978), page 12.
51 *The New York Times*: July 8, 1966.
52 *The New York Times*: April 27, 1968.
53 *The Los Angeles Times*: June 18, 1993.
54 *Home Fashions Textiles*: June, 1980.
55 *The Oakland Tribune*: June 13, 1970.
56 *Daily News*: October 17, 1975.
57 *The Oakland Tribune*: June 13, 1970.
58 *The Oakland Tribune*: November 21, 1974.
59 *Washington Star*: October 4, 1972.
60 *Washington Star*: October 4, 1972.
61 *The Dallas Morning News*: July 3, 1985.
62 *The Dallas Morning News*: July 3, 1985.
63 *The Washington Post*: May 28, 1978.
64 *The Dallas Morning News*: January 31, 1987.
65 *The New York Times*: September 25, 1977.
66 *International Herald Tribune*: November 13, 1993.
67 *The Oakland Tribune*: November 21, 1974.
68 *Casa Grande Dispatch*: August 26, 1975.
69 *The Self-Made Man,* Isadore Barmash (The Macmillan Company, 1969), page 302.
70 *The San Antonio Express-News*: January 30, 1966.
71 *The Washington Post*: May 28, 1978.
72 *The Oakland Tribune*: November 16, 1972.
73 Company literature.
74 *The San Antonio Express-News*: January 30, 1966.
75 *Casa Grande Dispatch*: August 26, 1975.
76 *The Dallas Morning News*: July 3, 1985
77 *The Oakland Tribune*: November 11, 1974.
78 *The Washington Post*: October 4, 1972.
79 *The New York Times*: September 25, 1977.
80 *The Free Lance-Star*: August 2, 1975.
81 *Textile Industries*: August 1966.
82 *Textile Industries*: August 1966.
83 *The Dallas Morning News*: July 3, 1985.
84 *The San Antonio Express-News*: January 30, 1966.
85 *The Fresno Bee*: August 10, 1972.
86 *The New York Times*: May 11, 1967
87 *The Washington Post*: October 4, 1972.
88 *The New York Times*: September 25, 1977.
89 *The Washington Post*: October 4, 1972.
90 *Twentieth-Century Pattern Design,* Lesley Jackson (Princeton Architectural Press, 2007), page 118.
91 *The New York Times*: September 25, 1977.
92 *The Washington Post*: October 4, 1972.
93 *The New York Times*: September 25, 1977.
94 *Daily News*: October 17, 1975.
95 *The New York Times*: March 27, 1961.
96 *The Free Lance-Star*: August 2, 1975.
97 *The Free Lance-Star*: August 2, 1975.
98 *Casa Grande Dispatch*: August 2, 1975.
99 *The New York Times*: June 19, 1975.
100 *The New York Times*: June 19, 1975.
101 *The Free Lance-Star*: August 2, 1975.
102 *The New York Times*: June 19, 1975.

About the contributors

SUSAN SEID *is an art lover and the owner of The Vera Company based in Atlanta, Georgia. She graduated from The Fashion Institute of Technology and has held various executive positions in the retail and direct marketing industry.*

JEN RENZI *is a freelance writer based in New York and has written for publications including the* New York Times Magazine, Surface, New York, Interiors, Wallpaper, *and* CondeNast Traveler. *Previously a senior editor at* House & Garden *and* Interior Design *magazines, she is the author of* The Art of Tile *and has written or contributed to a number of design books.*

STEVEN MECKLER *is a commercial photographer based in Tucson, Arizona. He has received numerous Advertising Federation awards and is the author of* Steven Meckler Photographs Tucson Artists.

Photo Credits

Acknowledgments

This book has required the passion, vision, talent, and dedication of many people including friends, colleagues, writers, photographers, and publishers. It takes everyone working together with the spirit necessary to create a beautiful book that will endure and inspire.

I would like to begin by thanking Jen Renzi for her wonderful words. She quickly captured the essence of Vera and the impact that her life and work has had on our lives. Her upbeat attitude and enthusiasm made it a pleasure to work together. Steven Meckler photographed hundreds of pieces of artwork and made them come alive. Other photographers lent their work to add historical context and texture as well. Thank you to our business partners who generously shared their photos of Vera products.

Heather Shields, who works every day in our environment surrounded by Vera's art, has held a special passion for her for many years. I want to thank her for her incredible dedication, diligence, and positive attitude to help make this project a success.

Our friends at Anthropologie have been great fans of Vera. With their support, this project has gone from being a dream to becoming a reality. I want to express my gratitude in particular to Wendy Wurtzberger, Keith Johnson, and Kelly Gilmore for their experience, counsel, and passion for this book.

A special thank-you goes to Vera's family members, friends, and former colleagues who generously shared their memories and mementos. Vera's son John Neumann and her granddaughter, Kimiko Matsuda, offered their personal remembrances for which we are very grateful. These all help to tell the story of the person behind the art.

More thanks to Rebecca Kaplan, our editor at Abrams who has guided this project from the beginning. We thank you for your commitment and guidance.

To my family and friends who have supported me on my journey, a sincere heartfelt thank-you. I wish for you the kind of passion that Vera has brought to my life.

Some time ago, we heard that Vera had hoped that someday a book would be written about her life and work. This is our homage to her and our way of saying "Thank you, Vera" for all that you have given to us.

—Susan Seid

Editor: Rebecca Kaplan
Designer: Sarah Gifford
Production Manager: Jacquie Poirier

Library of Congress Cataloging-in-Publication Data

Seid, Susan.
 Vera / by Susan Seid with Jen Renzi; contribution by The Vera Company.
 p. cm.
 ISBN 978-0-8109-9604-5
 (Special Edition ISBN 978-0-8109-8904-7)
 1. Neumann, Vera. 2. Textile designers—United States—Biography.
 I. Neumann, Vera. II. Vera Company. III. Title.

 NK8898.N46R46 2010
 746.092—dc22
 (B)
 2009030150

Photography credits:
Page 41 © 2010 Calder Foundation, New York/Artists Rights Society (ARS), New York
Page 48 © 2010 Bert Stern
Additional photography credits are listed on page 206

Printed and bound in China
10 9 8 7 6 5 4 3 2

Abrams books are available at special discounts when purchased in quantity for premiums and promotions
as well as fundraising or educational use. Special editions can also be created to specification. For details,
contact specialmarkets@abramsbooks.com or the address below.

THE ART OF BOOKS SINCE 1949
115 West 18th Street
New York, NY 10011
www.abramsbooks.com

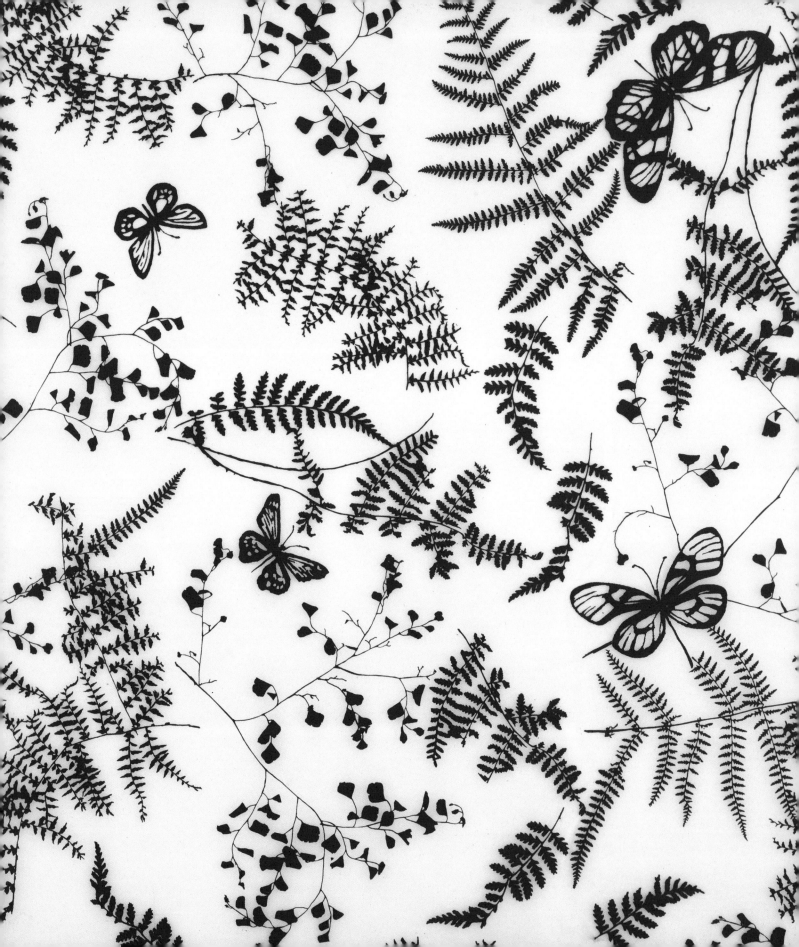